The inner section of the reflection is Nature with all instruction.

Alligator Lake, a coastal dune lake, hosts communities of cattails and water lilies.
The park straddles the outlet to the sea of St. Andrew Bay, with its eastern half
on Shell Island. *St. Andrews State Park, Panama City, Bay County.*

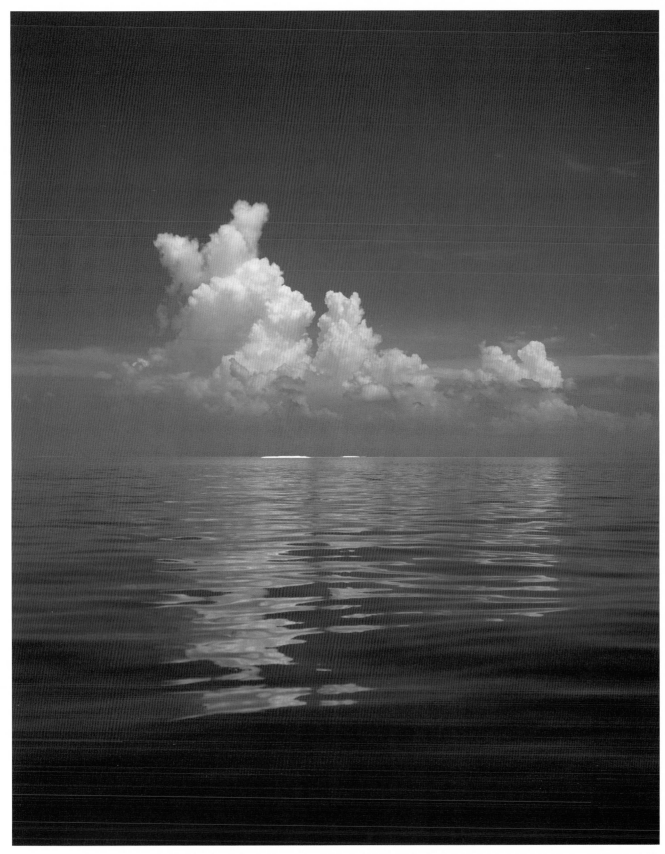

Islands in time connect with sky.

A distant sandbar emerges in the waters of the *Dry Tortugas, Fort Jefferson National Monument.*

Facing Page:
The gentle and slow-moving West Indian manatee *(Trichechus manatus)* lives in shallow, slow-moving rivers, estuaries, saltwater bays, canals, and other coastal waters in Florida, but ranges through coastal Atlantic waterways all through Central and northern South America. Living up to 60 years, females mature at about five years of age and have only one calf every two to five years. *Homosassa Springs Wildlife Park.*

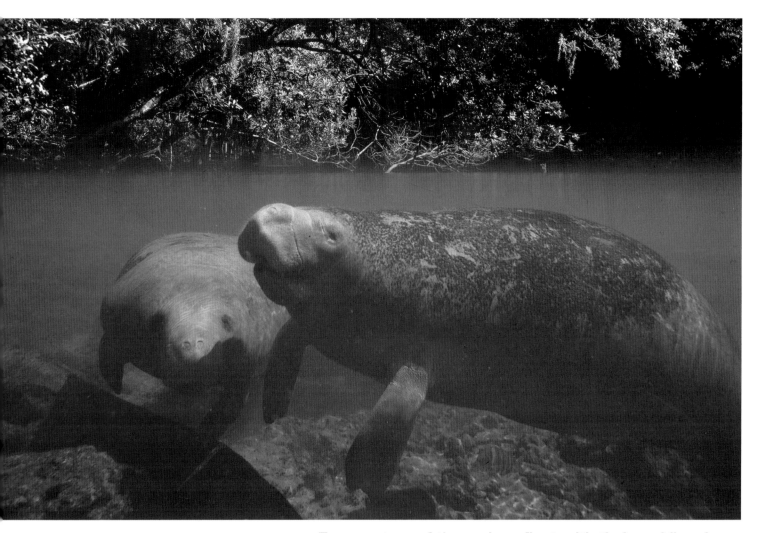

Zen masters of the springs float with their paddle wings.

Florida's
Magnificent
Water

James Valentine
and **D. Bruce Means**

Pineapple Press, Inc.
Sarasota, Florida

Epiphytes are plants that live on plants. All plants need water, but rain alone won't do for epiphytes. They also need high humidity, which is most abundant in the semitropical, southern third of Florida. Bromeliads (*Tillandsia* sp.) grow profusely on pond apple and other woody plants in this slough deep in the Everglades. *Fakahatchee Strand State Preserve, Copeland.*

Enveloped by noonday light, illuminating all your senses.

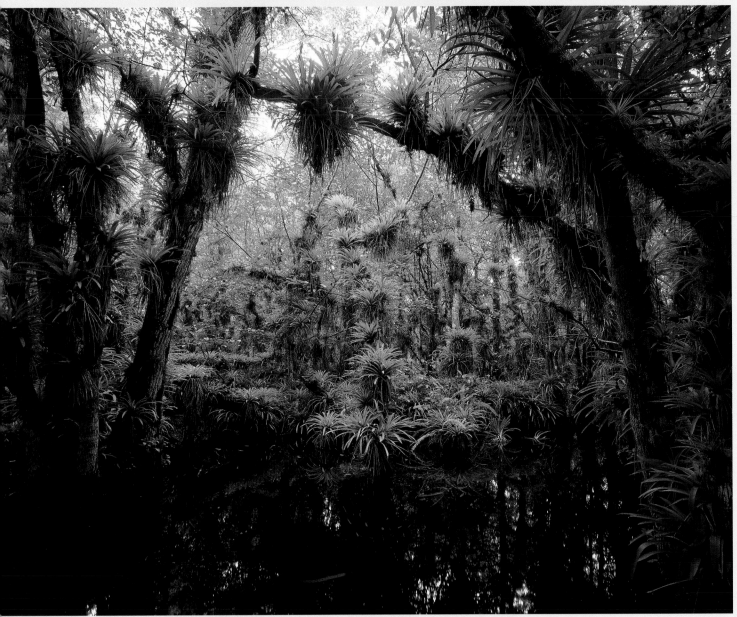

Inquiries should be addressed to:
Pineapple Press, Inc.
P.O. Box 3889
Sarasota, Florida 34230

www.pineapplepress.com

Design: Doris Halle
Printed in Malaysia

Library of Congress Cataloging-in-Publication Data

Valentine, James.
 Florida's magnificent water / James Valentine and D. Bruce Means. — First edition.

Summary: "Many years in the making, the Florida's Magnificent series is a visual journey through some of the most precious wild areas in the state, presenting the breathtaking beauty preserved in state lands, parks, and natural areas. World-famous nature photographer James Valentine has captured with his camera environmental art images of Florida's remote wilderness places, spectacular sites too often missed by both visitors and residents. Valentine also offers his poetic interpretations of the meaning of his images. Dr. D. Bruce Means, founder and president of the Coastal Plains Institute and Land Conservancy, has written the main text and captions in these volumes, which cover Florida's magnificent land, coasts, and water." —Provided by publisher.

ISBN 978-1-56164-720-0 (paperback : alkaline paper)

1. Florida—Pictorial works. 2. Bodies of water—Florida—Pictorial works. 3. Lakes—Florida—Pictorial works. 4. Wetlands—Florida—Pictorial works. 5. Rivers—Florida—Pictorial works. 6. Coasts—Florida—Pictorial works. 7. Groundwater—Florida—Pictorial works. 8. Natural areas—Florida—Pictorial works. 9. Natural history—Florida—Pictorial works. 10. Florida—Environmental conditions. I. Means, D. Bruce. II. Title.
 F312.V3557 2014
 975.90022'2—dc23
 2014022982
First Edition
10 9 8 7 6 5 4 3 2 1

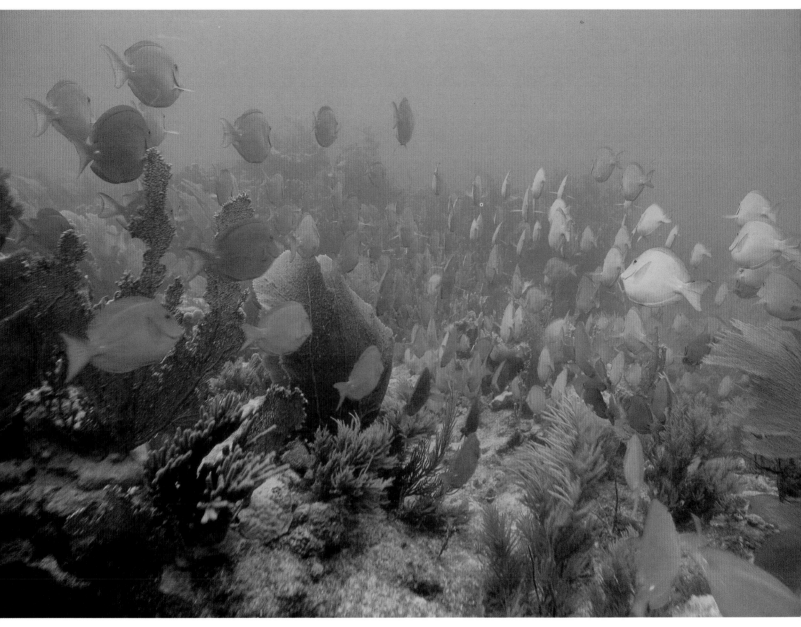

The nature of change is the flow of the universe.

Schooling Atlantic blue tangs *(Acanthurus coeruleus)* swim among sea fans and soft corals, grazing on algae, their main food. Juveniles are bright yellow but stay hidden in holes and crevices during the day. *John Pennekamp Coral Reef State Park, Key Largo.*

Preface

Jim Valentine

The poetry in this book attempts to acknowledge that the evolving attributes of nature and the sacred creative life force that permeates all of life work together, as one, fashioning an awe-inspiring world and universe. It is my firm belief that our very survival depends on a healthy and ecologically balanced world. The fine art landscape images were taken primarily on large format (4x5 film) cameras with special 35mm cameras used to portray wildlife. The large format provides the quality that I demand especially when producing large fine art mural archival prints. Sometimes I return to a special location many times to capture the special light and many other environmental factors. Other times the light is at its best as the gift of creation makes itself immediately known when you arrive on site and it is all that you can do to capture the image in a timely manner.

—Jim Valentine

You are on a Wilderness Watersphere journey. Imagine yourself flowing with and into aquifers, springs, and sinkholes. This is Florida, a land surrounded by water coming from all directions.

For millions of years, the power of water has traveled through the Florida wilderness-scape. Each spring and summer, enormous thunderstorms form above the southeastern United States to release their largesse upon the earth. This water filters through porous limestone, rocks, sand, and clay to navigate along solution channels below the Earth's surface. Out of aquifer cave systems below the surface of the earth, more than 300 major springs ascend into the semitropical environments of northern and central Florida. Many of these springs are first magnitude in size, natural beauty, and flow. They can be compared to our own circulatory system: Over sixty thousand miles of veins and arteries transport life.

Some of Florida's aquifers and springs contain water from hundreds of miles away, their underground origin in Georgia. This water makes its way through cave systems into our state. The human internal oasis of life is dependent on drinking fresh water from the springs and aquifers. We cannot exist without clean, clear water, and the best is from aquifers that have purified it after being filtered through thousands of miles of minutely porous limestone and sand hill recharge areas. The question is: Since the springs and aquifers are protecting our life, are we protecting them? I grew up on Estero Island and frequented artesian wells created by gushing spring water along the lower Caloosahatchee River. Some naturally plumed over fifteen feet high from the underground aquifer twenty-four hours a day.

While on location with a special permit to photograph the West Indian manatee at Homosassa Springs, I had a memorable experience (title page). Images of a manatee were taken from inside a clear camera housing, open at the top, which allowed me access to all camera controls while seeing my subject through a special anti-distortion optical

One of Florida's 33 first-magnitude springs flows into Econfina Creek north of Panama City and into an impoundment called Deer Point Lake, which supplies drinking water to tens of thousands of people living in Bay County. *Gainer Springs, Bay County.*

Florida's Wilderness Watersphere— spring yourself into life.

The upper Suwannee River in spring flood displays a diverse hardwood forest along its valley sidewall. Here the Suwannee River is largely a blackwater stream draining the Okefenokee Swamp. Downstream it is charged with clear spring waters from the Floridan aquifer system.

Embraced by light, we feel the flow of magical waters.

system at water level. There was enough room in my camera box to stow some carrots, a favorite snack of the manatee. Everything was going fine until one very ambitious manatee saw the carrots in my clear box. To my surprise, the gentle giant's nose was soon lifting my entire still camera system out of the water. Yes, he got a carrot! Enjoy your journey into the beauty of Florida's springs, aquifers, and sinkholes. Their gift to you is a healthy good life.

Your Florida Wilderness Watersphere journey now takes you into Florida's rivers, lakes, swamps, wet prairies, bays, estuaries, fresh and salt marshes, underwater, and open ocean. Along these lush semitropical waterways, we see just how important the rivers, lakes, and swamps are. Florida has more the 2,700 rivers and streams. If you really want know what Florida is all about, you take as much time as you desire and float with the flow of the magnificent Suwannee River, starting at its origin in the Okefenokee Swamp and ending at the Gulf of Mexico. You will have a life-changing experience.

Florida has four rivers that produce rapids. Three of these are the Suwannee River (Page 46), the Aucilla River (Page 27, bottom), and the Upper Hillsbourgh River (Page 60, bottom). I was in my homemade wooden strip boat approaching the beginning of the Aucilla River rapids and did not imagine I would have problems. As I went through the main run, I could hear the wood break on the rocks. To get help, I had to walk almost eight miles in the hot summer sun to finally get someone to bring my boat out of the Aucilla. These rapids are the source of much life and hold special aquatic creatures.

Florida's swamps are one of the highlights on Earth. Water environments are home to some of the most spectacular tree species. In 2013 Florida celebrated the 500th anniversary of Juan Ponce de León's arrival here. But long before he set foot on our land, there stood a pond cypress at the headwaters of the Green Swamp (page 38). This noble giant still had small green leaves coming out of its canopy and could now possibly be over eight hundred years old.

It is a major event to wade up to your chest with a 4x5 view camera into the center of the Fakahatchee Strand to locate the "Guzmania Gulch" (copyright page). It took four hours to reach the center of the swamp. That's when things intensified. Two minutes after my photography was complete, I heard what seemed to be a freight train approaching. The sound was a wall of water produced by a severe summer thunderstorm. It got very dark and rained so hard that visibility was reduced to twenty feet. Lightning cracked overhead while I was standing chest deep with an alligator swimming close by.

Bays, estuaries, fresh and salt marshes along each coast make Florida one of the most ecologically diverse coastal places on earth. Marshes, the nursery to the sea, provide homes for countless aquatic creatures, each with its own function to make the system complete. Florida's underwater and open ocean world gives us a Caribbean feeling with all its diverse sea life (pages 5 and 64). Enjoy your journey into the watery flower state.

Introduction

D. Bruce Means

Florida is abundantly endowed with one of life's most precious requirements: *water*. And Florida's 1,350 miles of coastline are the nation's second longest contact with saltwater. Fresh water is freely available in Florida in the form of rivers, streams, lakes, ponds, seepage, and in a huge subterranean reservoir called the Floridan aquifer system. Ultimately, all of Florida's fresh water comes from the world's oceans. Water evaporates from the surface of the seas and is carried over land in the air where it falls to the ground as rainfall. Thereafter, it may re-evaporate directly into the air, run off into streams, sink into the soil and recharge aquifers, or accumulate in lakes. Eventually, rainwater works its way back to the sea to complete what is called the hydrological cycle. A good way to visualize the importance of the ocean as the source of the world's fresh water is to imagine what would happen if rainfall ceased. Rivers and streams soon would run dry. Aquifers would discharge their waters into the sea or would equilibrate with sea level. Lakes and ponds would evaporate. Florida would soon become a barren desert.

On the other hand, the presence of water, salty or fresh, standing or flowing, briefly occurring or permanent, and water chemistry have everything to do with the animals and plants in a given ecosystem. Ecosystems—or habitats—that are affected by water are so numerous that it would require several books to do justice to each kind. Here we mix them all together, but ecologists categorize Florida's magnificent waters in the following way. A freshwater wetland is any ecosystem where water stands long enough for organic matter to develop in the soil and for special plants to survive the inundation. These are obligate wetland plants not found in the true uplands. They may be woody plants, such as trees and shrubs, in which case the wetland is technically called a swamp, or herbaceous plants, such as grasses and forbs, whose presence defines a marsh. In all wetlands, the plants are emergent from the water as floating or upright herbs, or trees and shrubs. Interestingly, in Florida, if emergent plants are present, the water is less than about five feet deep. Freshwater ecosystems that have no emergent plants are purely aquatic habitats. These include lakes, rivers, and ponds.

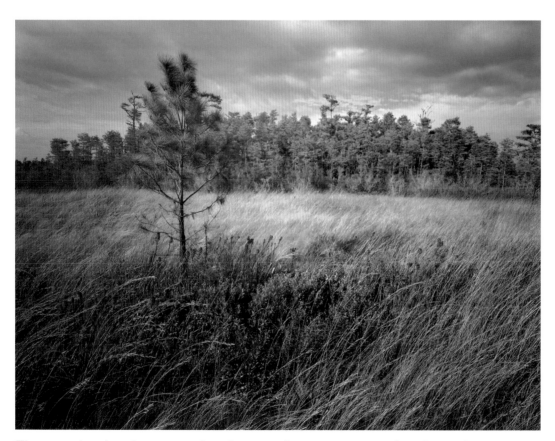

Garcon Point in Santa Rosa County lies on a small peninsula between Escambia and East bays of Pensacola Bay. It is the crown jewel of the Yellow River Marsh Preserve State Park, featuring an extensive pitcher plant wet flat and the federally threatened reticulated flatwoods salamander, *Ambystoma bishopi. Garcon Point, Santa Rosa County.*

The moving landscape refreshes each moment—reshaping who we are.

Flowers—plant's pinnacle of beauty.

Wildflowers of the Apalachicola National Forest, left to right: Chapman's fringed orchid (Platanthera chapmanii), northern pitcher plant (Sarracenia rosea), and yellow pitcher plant (Sarracenia flava). Vast acreages of pitcher plants occur in wet flats in the Apalachicola National Forest in Liberty County.

Wells and SCUBA diving in caves and sinkholes in the past two decades have demonstrated that the Floridan aquifer system is a huge complex of large and small tunnels dissolved in the limestone by circulating groundwater. Rainfall sinks into the sandy soils of the highlands of Florida and makes its way down to underlying limestone, where it eventually moves through cracks and fissures into horizontal passageways. These passageways are very much like surface drainage patterns in that they all bring water toward the sea, or to the lowest lying terrain that is occupied by the regional master stream of the region, such as the Suwannee River.

Confined in tunnels, circulating groundwater is under hydraulic pressure as it progresses down-gradient. Eventually, as it reaches low-lying terrain near the seacoast or the master stream, it is forced on top of the ground to emerge as one of more than 720 Florida springs, after which it either joins the surface waters of the master stream or it flows independently to the sea in its own beautiful channel of crystal clear waters.

Florida is one of the few places in the world gifted with many spectacular aquifer-fed springs, 33 of which are first magnitude (having a discharge greater than about 65 million gallons per day). Discharge from all 720 springs is greater than eight billion gallons per day. By comparison, all fresh groundwater pumped in 1975 in Florida totaled only 3.3 billion gallons per day. Altogether in the U.S., there are at least 84 first-magnitude springs. With 33, Florida has more than any other state. Next in order are Oregon and Idaho with 15 and 14, respectively.

In descending order of average flow, Florida's top nine springs are: Spring Creek, Crystal River, Silver, Rainbow, Alapaha Rise, St. Marks, Wakulla, Wacissa, and Ichetucknee. Spring Creek Springs is actually a series of 14 or more separate outflows that emerge under the estuary on the Gulf Coast of Wakulla County. At a discharge of more than 1.3 billion gallons per day, Spring Creek Springs is a leading candidate for the world's largest spring. It disgorges more than twice the outflow of Florida's most famous and third largest, Silver Spring, at 0.6 billion gallons per day.

Florida's springs have two relatively constant physical features. They all are laden with minerals dissolved from the limestones in which they circulate, namely bicarbonates, carbonates, calcium, magnesium, chloride, fluoride, iron, manganese, strontium, sulfate, and zinc. This makes their water relatively hard and slightly alkaline, but highly drinkable. Another feature is their constancy of temperature. Water emerging from Florida's springs is relatively constant in temperature year-round, but varies from spring to spring depending upon location. Spring water temperatures tend

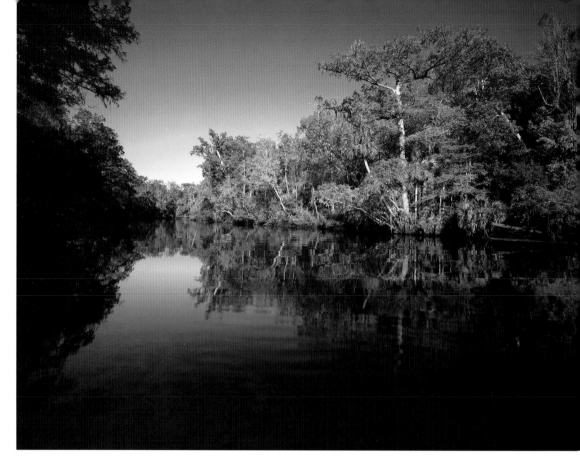

Fall colors in cypress trees along the St. Marks River of Wakulla County. Sinkholes in Leon County form the headwaters of the St. Marks River. The river receives spring water inputs of the Floridan aquifer system as the river flows to its confluence with the Wakulla River, whose principal source is the first-order Wakulla Springs. *St. Marks River, Wakulla County.*

Your inner consciousness reflected in Nature's reflection.

to track the average annual temperature at the local ground surface. Springs in north Florida, therefore, tend to be quite cool, ranging from 66–70° C, while spring waters from central to south Florida emerge in the range of 71–77° C.

Where the Floridan aquifer system is deep underground, Florida's groundwater is perched above it in surficial aquifers. In parts of north Florida downslope from uplands, the first evidence of seepage usually is an herb-dominated habitat called seepage bog. If the number of plant species that can be packed into a square meter is any indication of the value of a habitat, then Florida's seepage bogs are among the most valuable habitats in the world. And if the number of species of carnivorous plants is a measure of habitat worth, then, too, Florida's seepage bogs rank among the best anywhere. In the seepage bog habitats of North Carolina's Green Swamp, botanists have counted over 50 species per square meter, which is North America's present record for plant species richness at that scale. There is every reason to believe that Florida's bogs are at least as rich, if not more so, though no formal study has yet measured their species abundance. Three of the world's five carnivorous plant families, represented by six pitcher plants, twelve bladderworts, six butterworts, and five sundews, can be found in various combinations in Florida's seepage bogs. A seepage bog is also called herb bog, grass-sedge bog, and pitcher plant bog; and a large one is called savannah bog or wet flat.

Seepage bogs are commonest in the Florida panhandle west of the Ochlockonee River, where limestone is not near the surface of the ground. Growing in the open sunlight, the herbs of Florida's seepage bogs are true heliophiles— sun lovers. Seepage bogs are the wildflower gardens of the Southeast. Although grasses and grasslikes, such as sedges, rushes, pipeworts, and yellow-eyed grasses, are the dominant plants of herb bogs, forbs (all the flowering plants except grasses) are abundant. There is always something abloom in seepage bogs. Early spring is when you see raucous displays of the large, exotic-looking pitcher plant flowers, followed closely by the rapid rise of their insect-trapping leaves. The bright yellow flower heads of the trumpet pitcher plant stand on two-foot-tall stems, soon to be overtopped by the three-foot-tall yellow-green pitcher-shaped leaves. Not to be outdone, in the same seepage bog, a patch of a hundred equally striking two-inch-diameter burgundy flowers stand sentinel alongside their delicate frill-edged white-top pitchers. At the edge of the shrub zone in wetter conditions, you have to search a little to see the garnet flowers of the parrot pitcher plant, whose parrot-beak-tipped leaves lie on their backs looking up. And inside the wettest shrub bogs lie the baroque leaves of the purple pitcher plant, whose three-inch-wide purple flowers could be considered the most spectacular of all.

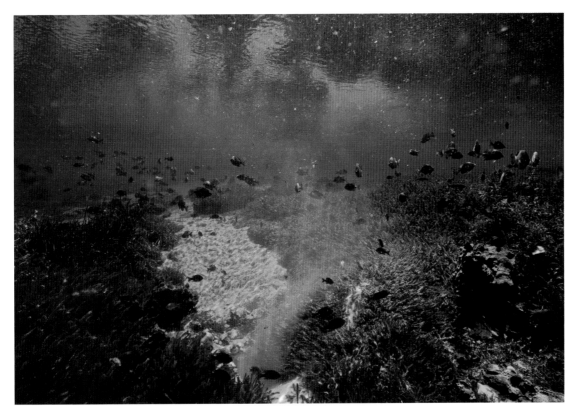

Head springs . . . oasis of love and life from the Earth.

While the pitcher plants put on their leafy show, deep in the vegetation you can find the sensuously soft yellow, blue, or white flowers of the butterworts, carnivorous plants whose rosette leaves have tiny beads of "stickum" dotting the leaf surface—nature's flypaper. If you get jaded by the sheer abundance of the showy carnivorous plants, you have only to wait a couple of weeks to view the earth's showiest flowers of all, the orchids. Beginning with the grass pink orchids, the seasonal procession brings out delicate rose pogonia and rosebud orchids, then ladies' tresses, and, in the heat of mid-summer, the fringed orchids. Meanwhile, ranks of pipeworts and white-eyed sedge, blue-eyed and yellow-eyed "grasses," and meadow beauties all come and go in bloom. By summer's end, after a little respite, the parade is far from over. September and October bring on the composites: blazing star, sunflower, goldenrod, dogfennel, coreopsis, aster, biglowia, and many more.

By one ecologist's estimate, 97 percent of the Gulf Coast seepage bog habitats have been destroyed by the careless actions of humans. Drainage associated with the conversion of bogs to cropland, pasture, or intensive pine-tree farming seems to have caused the most bog loss, but humans also have paved the way for woody plants to invade the herb bogs. Shrubby growth of several species of small-leaved evergreen plants, such as black and swamp titi, dahoon holly, large gallberry, odorless myrtle, and fetterbushes, normally are found downhill from herb bogs in wetter sites near stream bottoms. These fire-sensitive plants readily invade upslope into herb bogs and even beyond into longleaf pine forests when natural fires are not allowed to burn down into them from the naturally incendiary longleaf pine forests. After a bog has been taken over by shrubs, most of the diverse herb community dies because the species are not adapted for the dense shade and altered water conditions.

The rivers of Florida maintain another group of the state's biologically rich wetlands. Bottomland forests of river floodplains are special habitats with unique species created by the high water that regularly and periodically spills out of the open-water channel. Floodplain swamp forests are not uniform across any given floodplain, however, because floodplains are not flat. Sediments are piled up during high-water stages in long parallel ridges called levees. Levee forests themselves are true wetlands, but when high water subsides, levees are the first to emerge and they remain dry longer than any other vegetation in the floodplain.

Downslope, water stands longer with decreasing elevation. Studies of Florida's river floodplain plant communities reveal that hydroperiod—the percentage of time during the year that water stands on a site—is a major factor governing the species composition of floodplain plant communities. For instance, on the Apalachicola River, a large alluvial

Water—the diverse supporter of all life's biodiversity.

(Below left) Coral reefs are made up of mineral deposits secreted by small colonial animals called polyps. The polyps live on plankton and sunlight utilized by symbiotic algae in their tissues. The reef provides nesting areas and hiding spots for numerous species of small fish and invertebrates, which attract larger fish to the reef. Coral reefs are among the most species rich communities in the oceans. Florida's John Pennekamp Coral Reef State Park, the first undersea park in the country, is one of only two living coral reef formations in the continental United States. *Key Largo, Monroe County.*

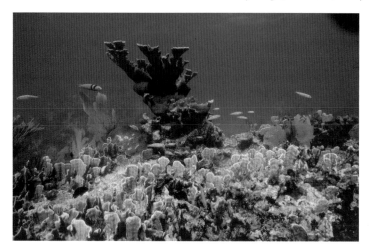

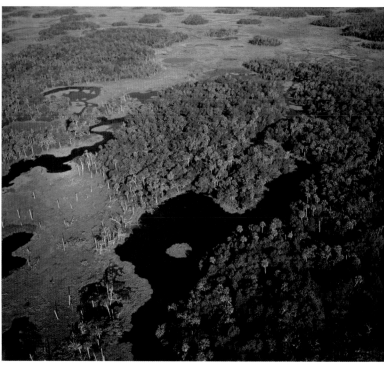

(Right) This photograph taken from the air shows a mosaic of hydric hammocks with cabbage palms, blackwater creeks, and freshwater marshes in the foreground that grade in the distance into brackish marshes and eventually the Gulf of Mexico. Acquired with Florida Forever funds, the Gulf Hammock State Wildlife Management Area is designed to protect a large forested system with a watershed draining into an aquatic preserve. *Big Bend Coast, Levy County.*

river of the Florida panhandle, it is the plant community of water hickory, sweetgum, overcup oak, green ash, and sugarberry, among other species, that dominates sites saturated or flooded 5 to 30 percent of the year, while the wettest river floodplain forest type, the cypress-tupelo swamp, may be inundated more than 50 percent of the time.

Florida's rivers fall into three main categories, depending upon water conditions. Panhandle Florida is the home of the classic alluvial rivers whose drainage basins originate deep in the continent and whose muddy waters are laden with silt and clay. Shed leaves and twigs of each year's plant growth provide a huge bank of rotting vegetation in river floodplains, from which dark-colored organic acids are leached during rains. These darkly stained waters are masked by the muddiness of alluvial rivers, but in small river basins with little clay and lots of sand, the black water stands out sharply against the white sands of the river bed and banks. Rivers such as these are called blackwater rivers, a second type of river. They run clear but tea-stained and are highly acidic and relatively low in nutrients when compared to other river types.

The spring-run, the third kind of river, is fed from deep waters of the Floridan aquifer system. These waters usually are crystal clear, cold, circumneutral in acidity, and laden with mineral salts picked up by the dissolution of limestone. During very heavy rains, however, these rivers will blacken briefly from the organic acids flushed out of their adjacent swamps. Blackwater and spring-run streams are commonest in peninsular Florida, where there are no alluvial rivers.

The type of river has a lot to do with the ecology of its floodplain. The bottomlands of alluvial rivers are very muddy because of the silts and clays in them. They are also very rich in nutrients, and trees grow exceptionally fast there. While fine sediments are transported into the floodplains of alluvial rivers during high-water stages, tons of partially decomposed vegetable matter are flushed downstream, eventually winding up in the estuaries at the coast. These plant fragments and the chemical nutrients that are leached from them are vitally important as food and nourishment for the highly productive saltmarshes and waters of the estuaries. The entire food web—from bacteria and algae to shrimp, oysters, crabs, and fish—is driven by these nutrients, demonstrating how interconnected our world can be. What happens to the water quality, trees, or the sediment supply of a river floodplain a hundred miles inland from the ocean can have a crucial impact upon the health of coastal fisheries.

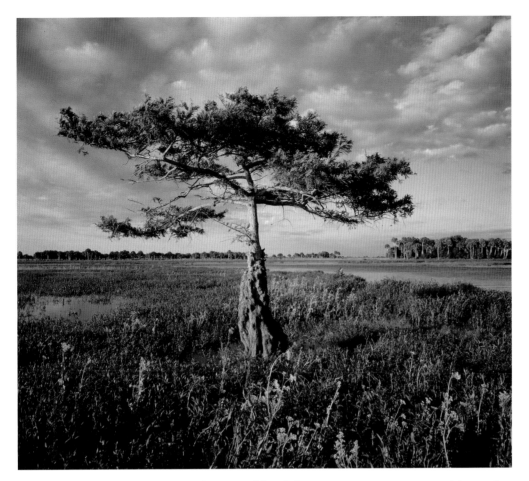

Smartweed *(Polygonum* sp.) and ragwort *(Senecio* sp.) carpet the floodplain marshes along the headwaters of the St. Johns River. A cabbage palm tree island grows across the open waters under the limbs of a lone baldcypress. *Tosohatchee State Reserve, Christmas, Orange County.*

Alone you can decorate the world with your own grace and beauty.

Florida's rivers all feed very productive coastal wetlands from extensive salt marshes on both coastlines of the upper peninsula to vast mangrove forests that wrap around the tip of south Florida. These mangrove forests extend into the sea from the Everglades and Big Cypress, vast freshwater marshes that once accounted for about one-third of the landmass of the peninsula. Drainage projects and agriculture have reduced their abundance, but restoration and maintenance of the Everglades is a perennial conservation objective.

When surface runoff erodes clay deposits down to limestone, such as in the Tallahassee Red Hills, dissolution of the limestone causes the stream to widen and deepen, eventually forming large lake basins. Lakes and ponds also form by the collapse of tunnels in the underlying limestone, which can cause steep-sided sinkholes or more gently inclined lake and pond basins. The myriad lakes and ponds of Florida—there are more than 7,800 greater than one acre in size—are almost exclusively of limestone solution origin. Florida's lakes are generally shallow with extensive marshes around their margins. Some have swamp forests of cypress and gum trees surrounding an open-water aquatic environment.

No discourse on Florida's magnificent waters can overlook the Atlantic Ocean and Gulf of Mexico. Because of their importance, the marine and estuarine environments are the principal focus of this volume. Ironically, even though Florida's fresh waters are so abundant and varied, the demand on them for human consumption and agricultural use is so great in parts of the state that local water supplies can be quite limited. For instance, aquifers have been drawn down so severely in Tampa and Jacksonville that the surface of the ground has dropped and foundations of homes have cracked. Panhandle Florida has been in a long water war with Alabama and Georgia for water coming down the Chattahoochee/Apalachicola River. As Florida's human population burgeons (now over 19 million and predicted to reach 30 million by 2030), adequate water supply will become more of a problem. It is not too early to realize that we are lucky to be so richly endowed with such a precious and life-giving commodity. It is not too early to devote more appreciation to other benefits that water gives us: clean streams and lakes, beautiful springs and wetland ecosystems, and salt marshes and estuaries that are the basis of Florida's considerable seafood industry. **—D. Bruce Means**

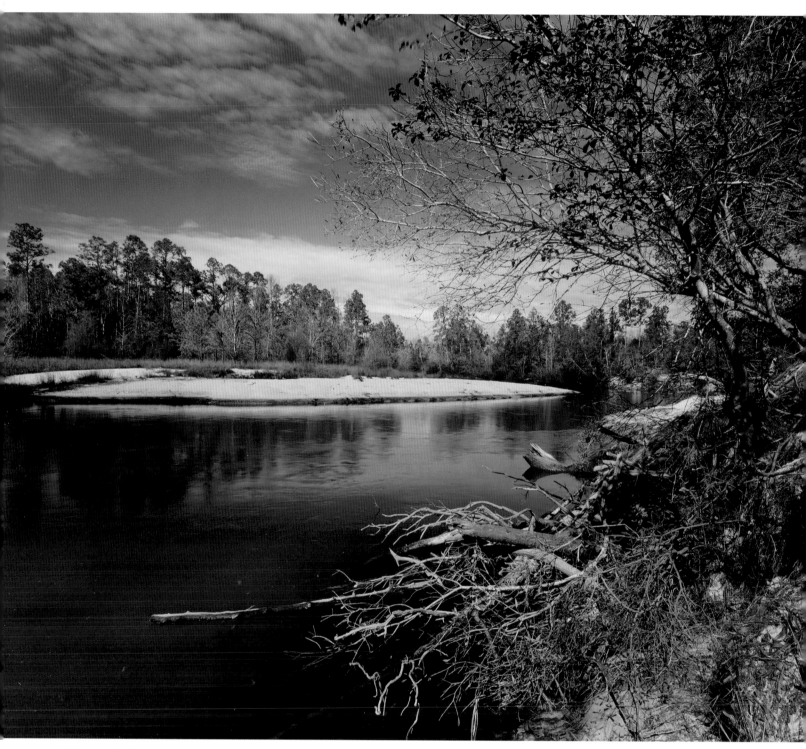

Meandering waters carry the consciousness of time . . . healing, flowing, undulating.

Florida's western border with Alabama is the Perdido River, a classic blackwater stream that flows sluggishly to the Gulf of Mexico. It is stained black by organic acids flushed by rainwater from swamps along its course.

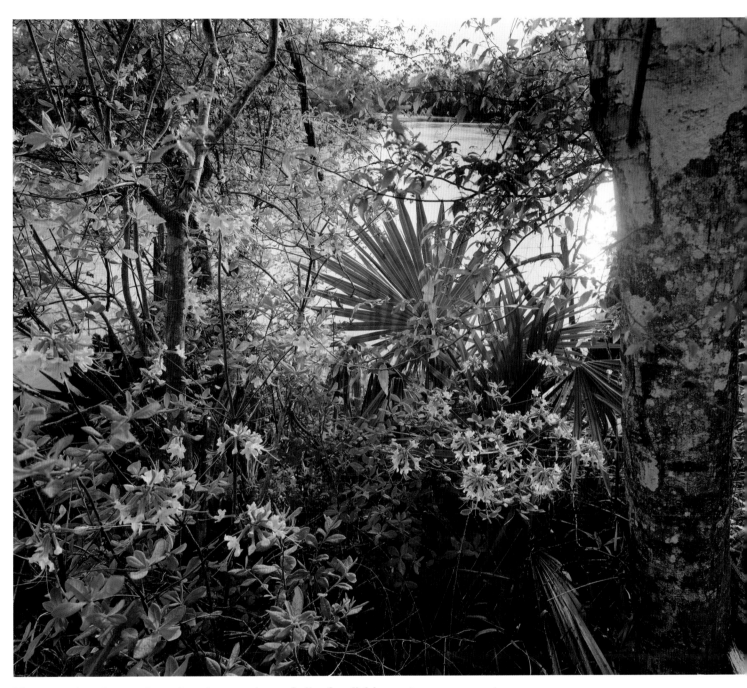

You can bank on river banks, a place full of wild beauty.

Orange azalea *(Rhododendron austrinum)* blooming in spring along west Florida's Escambia River. This showy plant is a regional endemic species from Mississippi to Georgia. *White River tributary of the Escambia River, Santa Rosa County.*

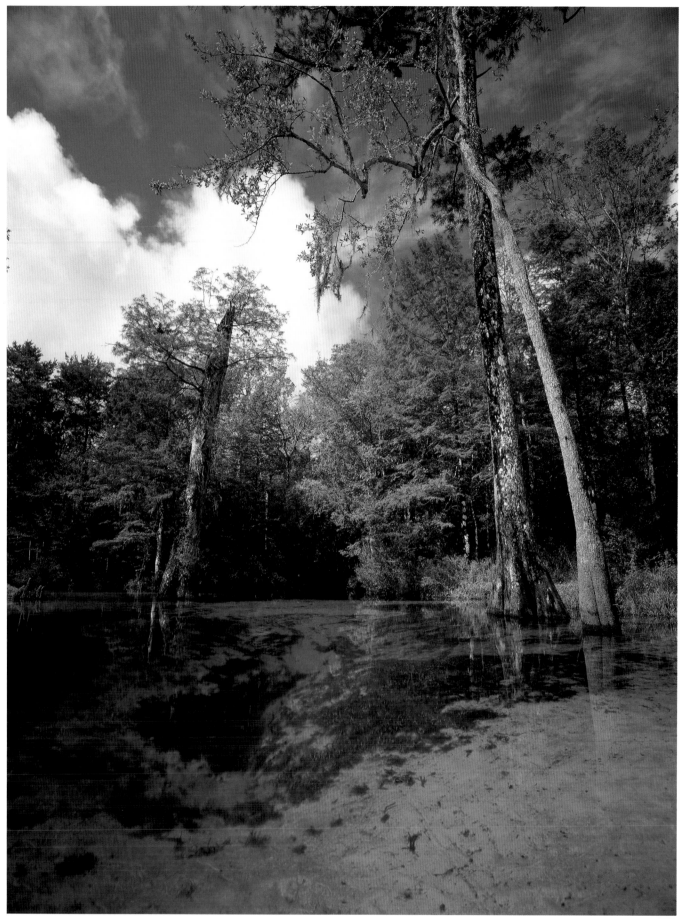

The flow of Nature connects us with the divine order of the Universe.

Black tupelo *(Nyssa sylvatica)* and baldcypress *(Taxodium distichum)* grow around the margin of a springhead, with a hardwood bottomland swamp forest beyond. The blue color of clear water comes from selective scattering of blue light, similar to the sky. *Ponce De Leon Springs State Park, Holmes County.*

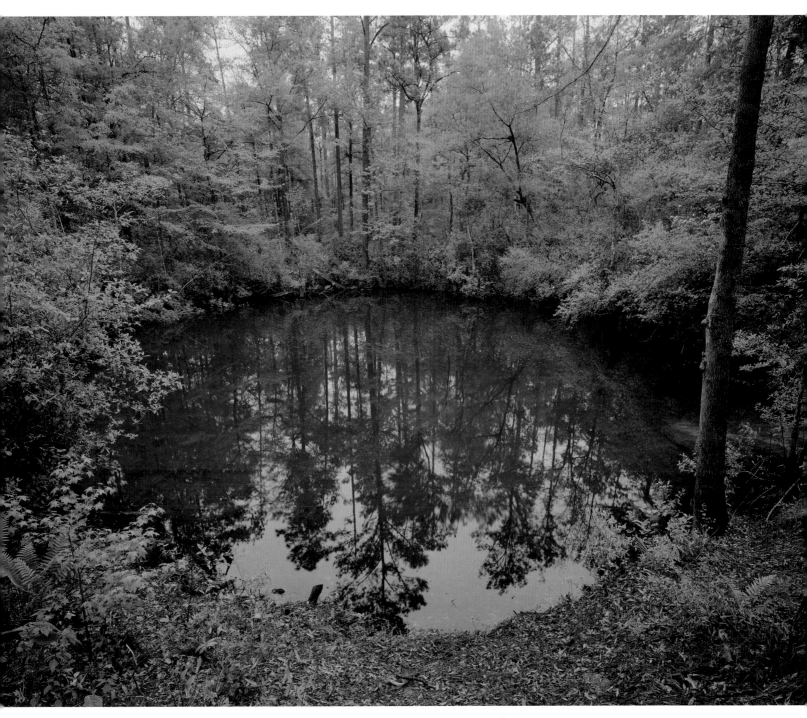

Our sacred Earth—such an upwelling of pure water consciousness.

Devil's Sinkhole is a window into the Floridan aquifer system. The overburden collapsed into an underground tunnel, through which circulating groundwater emerges not far south of this site as springs in the bed of *Econfina Creek, Bay County.*

Light brings eternal joy.

Just as sunrise brings a new day, baldcypress *(Taxodium distichum)* trees resprout from stumps in the middle distance beyond the uncut cypress. Cypress knees never produce stems, but cut trunks often produce dozens of suckers, one of which eventually assumes dominance and replaces the tree that once was. *Campbell Lake, Topsail Hill Preserve State Park, Walton County.*

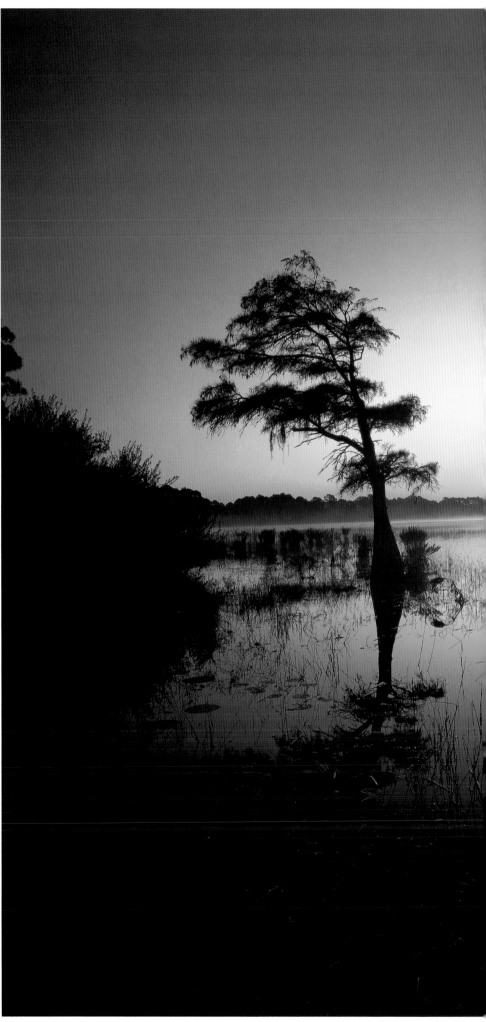

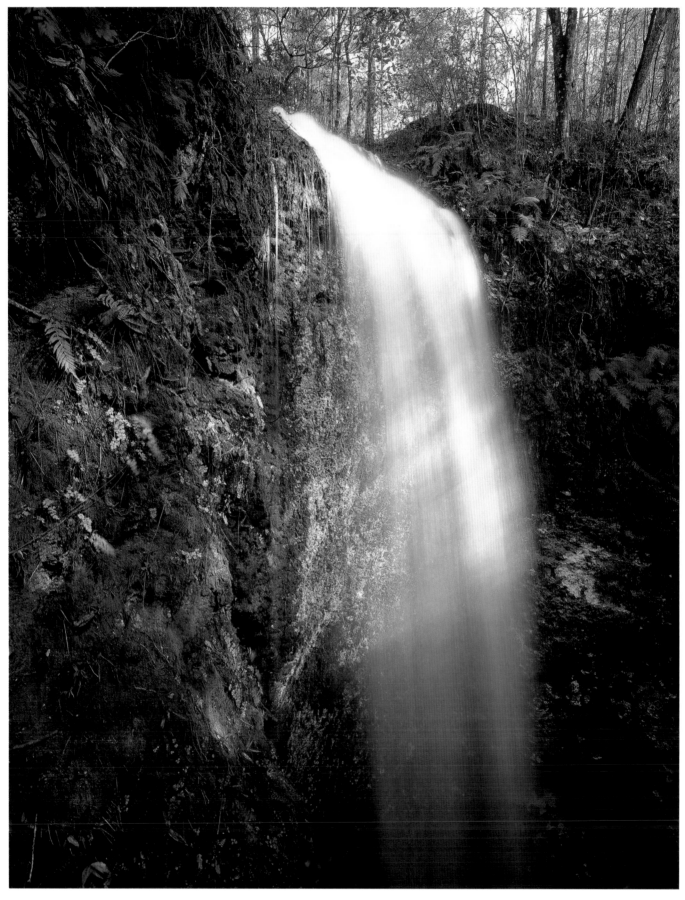

Nature doesn't waste a drop to purify the inner Earth.

A small stream plunges into the circular shaft of a solution pipe that the stream has dissolved over eons of time. The stream, recharging the aquifer at this point, will flow into underground passageways of the Floridan aquifer system, Florida's main source of drinking water. *Falling Waters State Recreation Area, Chipley.*

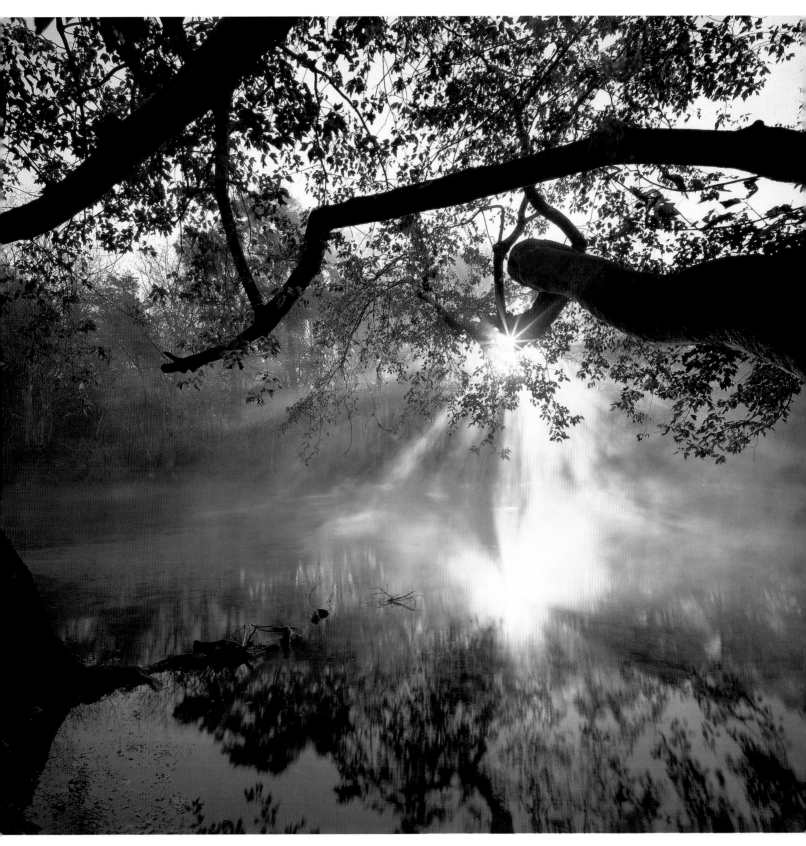

Nature embraces all with inner truth.

Early light on a cold January morning creates a special mood as it filters through the leaves of an old red maple tree. Spring water temperature remains about 69°F year-round here, but in winter, when the air temperature is colder, fog rises from the warmer spring water. *Cypress Springs, Washington County.*

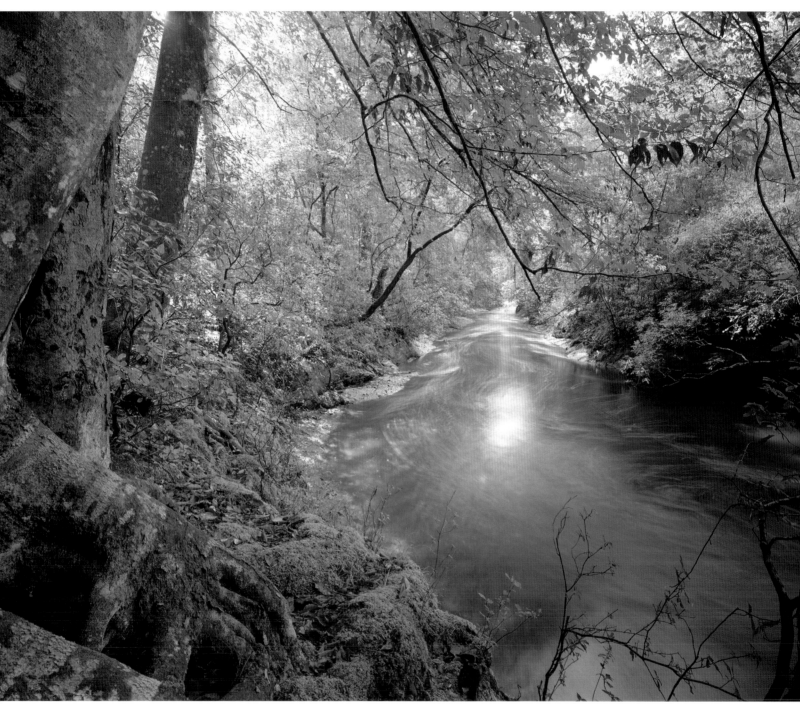

A miracle happens every day.

Econfina Creek is the central feature in the heart of a 40,000-acre native habitat corridor. The creek has steep slopes with feeder springs, surrounded by upland sinkhole lakes serving as a recharge area. Rich hardwood forests clothe the bottomlands and valley slopes. *Northwest Florida Water Management District, Bay and Washington Counties.*

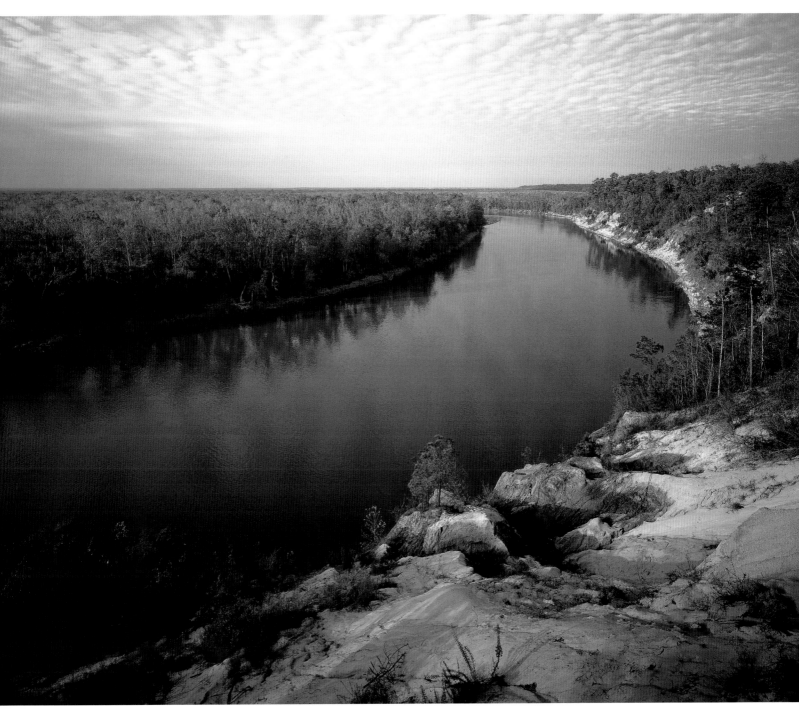

Ancient guardians hold the timeless spirit of wilderness.

Facing a magnificent floodplain swamp forest across the river, Alum Bluff is the highest bluff in Florida. Here the powerful waters of an outside bend on the Apalachicola River, Florida's largest, are eroding the foot of the high bluffs and facilitating fresh landslides— a natural process. *The Nature Conservancy's Apalachicola Bluffs* and *Ravines Preserve, Bristol.*

Clear, potable water flows from unique springs called steepheads draining the sands of ancient barrier islands stranded inland along the Apalachicola River. Florida pinxter azalea *(Rhododendron canescens)* in bloom indicates a spring scene. A local preacher once believed this area was the true Garden of Eden. It is now owned and managed by The Nature Conservancy as the *Apalachicola Bluffs and Ravines Preserve, Liberty County, Bristol.*

(Below) White pitcher plants *(Sarracenia leucophylla)* grow on a submerged bed of peat that has built up along the edge of *Liveoak Creek, Eglin Air Force Base, Okaloosa County.*

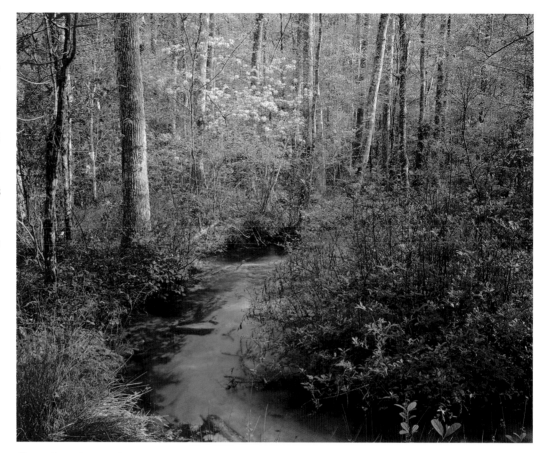

Our Garden of Eden—a place of special earth beholden.

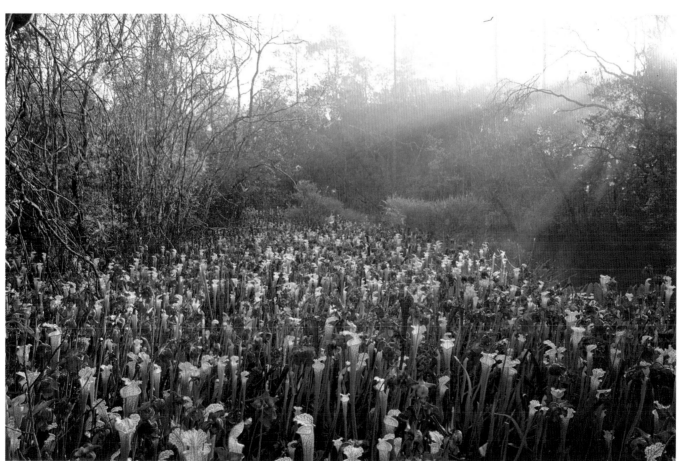

Bountiful beauty knows no boundary.

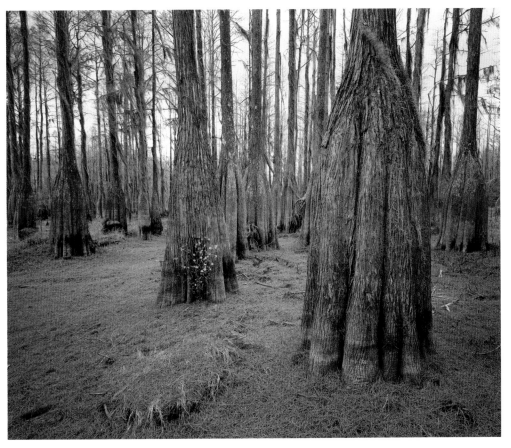

Cypress trunks and knees swell to the average height of local high-water events. These bottle-shaped trunks tell a story that high water here pipes off out of the swamp at the level of the tops of the swollen bases and cannot rise further. *Green Pond, Sand Hill Lake Mitigation Bank.*

(Below) The reddening needles of pond cypress *(Distichum ascendens)* contrast strongly with the pines behind them in November. Most conifers lose their leaves (needles) a few at a time so that the trees are never bare at any season. Cypresses, however, are among the few deciduous conifers that lose their leaves like many deciduous hardwood trees do. *The Deadening, Washington County, Northwest Florida Water Management District, Florida.*

Delicate bouquet . . . your domain so soft awaits water.

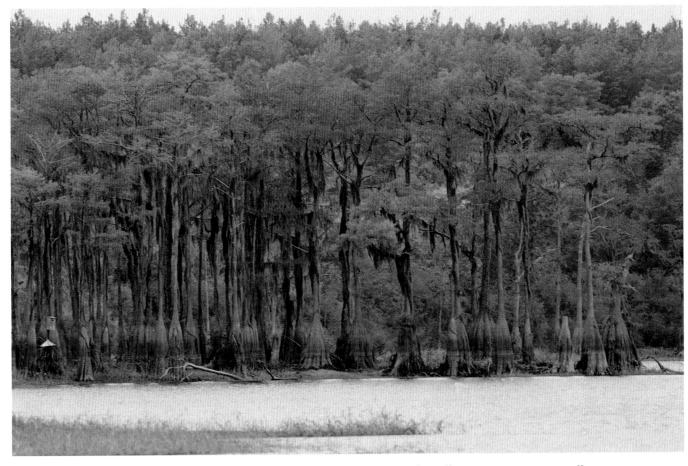

Together we decorate the sky with a glowing crown of radiant cypress needles.

Streambank spider lily *(Hymenocallis rotata)* grows on rich soils of limestone banks. Soils derived from limestone are richer than soils developed from clays and sands. Scattered around the state, limestone soils support a rich variety of plant life. *Chipola River, Marianna.*

(Below) On Christmas Eve of 1989, at a frigid temperature of 9° F, a rare north Florida snow fell upon Falling Creek Falls. Southern swamps normally conjure mental images of blackwater, moss-draped cypresses, humidity, and sweltering heat. To see a swamp beautifully cloaked in pure white—and cold—snow is incongruous but fantastic. *North Suwannee River area, White Springs.*

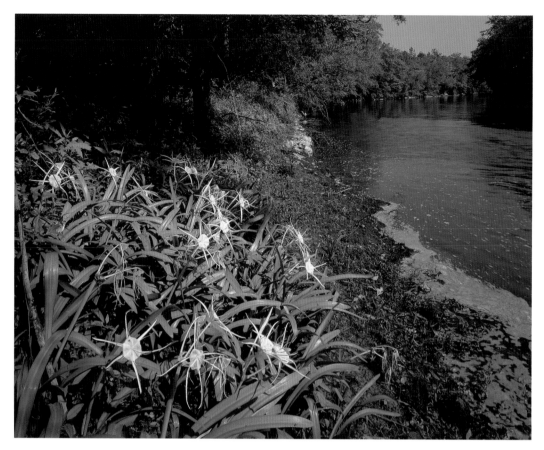

Water's journey . . .
what a miracle as it passes by and over the fringes of Nature.

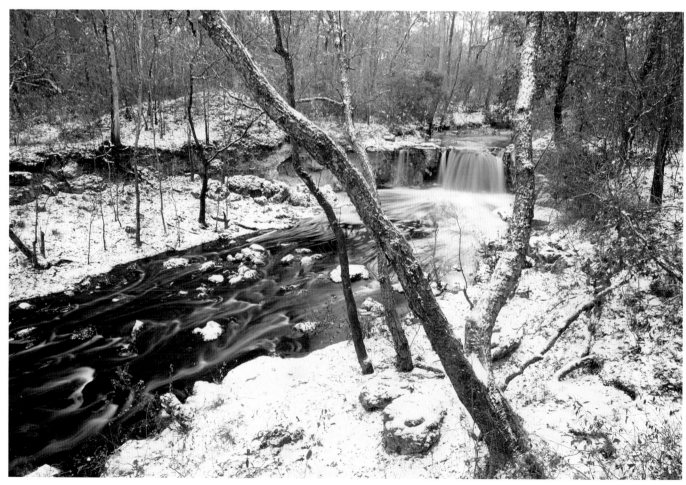

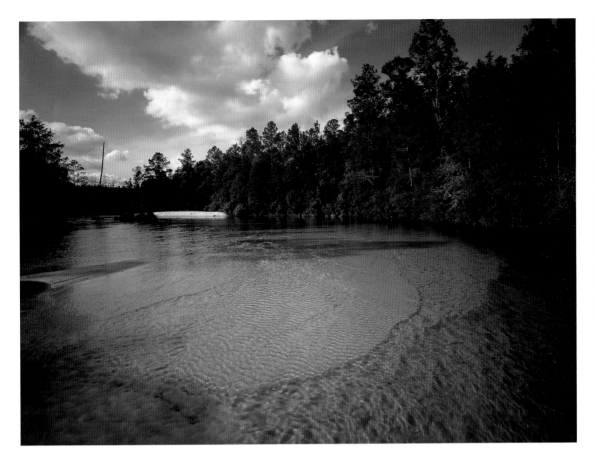

Blackwater streams flow where sand is abundant and clays and silts are absent. Atlantic white cedar *(Chamaecyparis thyoides)*—locally called juniper—grows along stream banks of the Florida panhandle. The tallest tree on the right is an Atlantic white cedar, which normally does not have a multiple trunk. *Juniper Creek, Santa Rosa County.*

Flowing, cascading, undulating, circulating—always cleansing our thoughts.

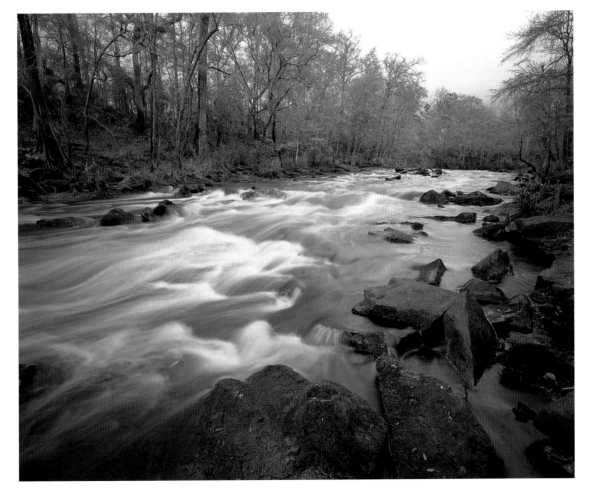

Hard, dolomitized limestone impedes the flow of the Aucilla River, one of the few places in Florida where rapids occur. Chert nodules in such places were the source of thousands of spear points and arrowheads knapped by Florida's first people. The river exposed the limestone and chert by dissolving and eroding a channel in a limestone plain. *Aucilla River, border of Jefferson and Taylor Counties.*

The leaves of black tupelo *(Nyssa sylvatica)* turn bright red in autumn, as seen along the shore in the distance. The aerial stems and leaves of marsh plants have died and added their biomass to the bottom sediments of the lake. Nature takes a nap: roots are alive still, just dormant for a few months. *Lake Hall, Alfred B. Maclay Gardens State Park, Tallahassee.*

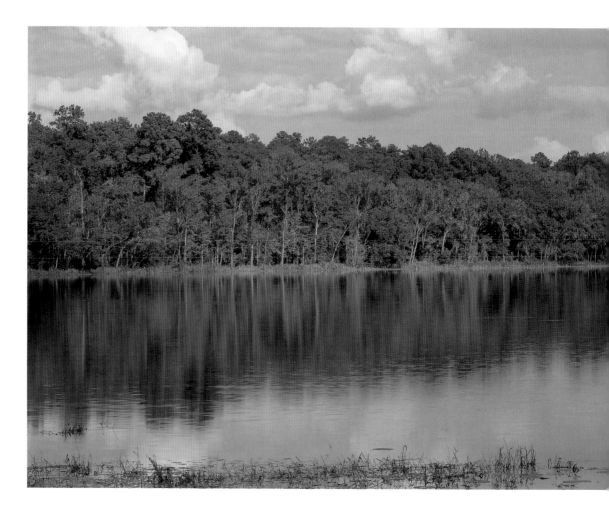

The freshness of the seasons sharpens the mind.

Hot and humid days of summer blend into balmy autumn. Yellowing cypress needles and browning cattails are not signs of loss, but the coming of a short winter's nap. Winter is less than three months long in north Florida. *Lake Victoria, Elinor Klapp Phipps Park, Tallahassee.*

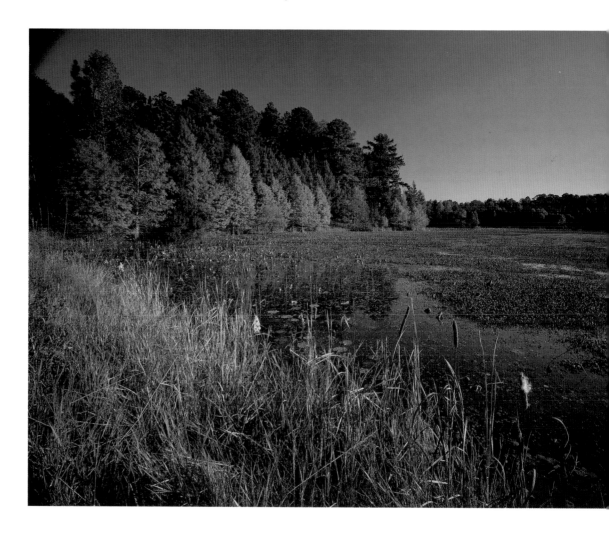

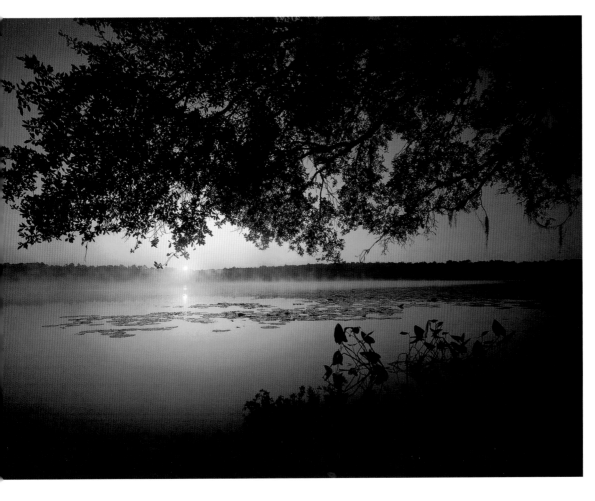

Sunrise under a liveoak (Quercus virginiana), pickerelweed (Pontederia cordata) emerging from the water in the foreground, and floating white water lily (Nymphaea odorata) paint a picture of spring on Lake Overstreet. It is critical to maintain the biological purity of these lakes via the implementation of conservation easements or parks in areas of heavy urban development. *Lake Overstreet, Alfred B. Maclay Gardens State Park, Tallahassee.*

Silken waters shimmer under the silent sun.

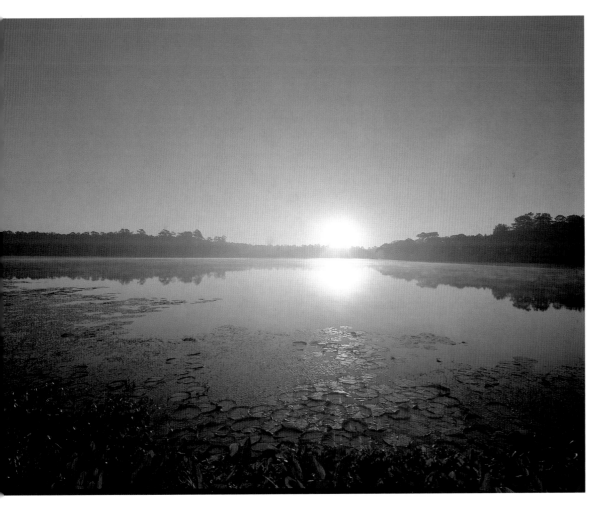

Sunrise over Lake McBride illuminates the headwaters of the Lafayette Drainage System that eventually ends in the St. Marks River. Lakes McBride, Hall, and Overstreet are all lakes in the red hills of Leon County that were formed over thousands of years through a series of sinkholes and sinkhole activity. These lakes are the last of the unpolluted lakes in Leon County; that is, they have not been over-nutrified from urban-suburban runoff. *Lake McBride, Tallahassee.*

Approximately 250 million gallons of fresh water flow daily from Wakulla Springs, one of Florida's largest and deepest springs. The massive underwater cave system averages more than 250 feet deep and is currently the site of the world's longest single SCUBA cave penetration at more than 20,000 feet, or nearly four miles. The brown bullhead *(Ictalurus nebulosus)* is the commonest catfish found in subterranean waters of the Floridan aquifer—here seen in a school 100 feet below ground surface. *Edward Ball Wakulla Springs State Park, Wakulla County.*

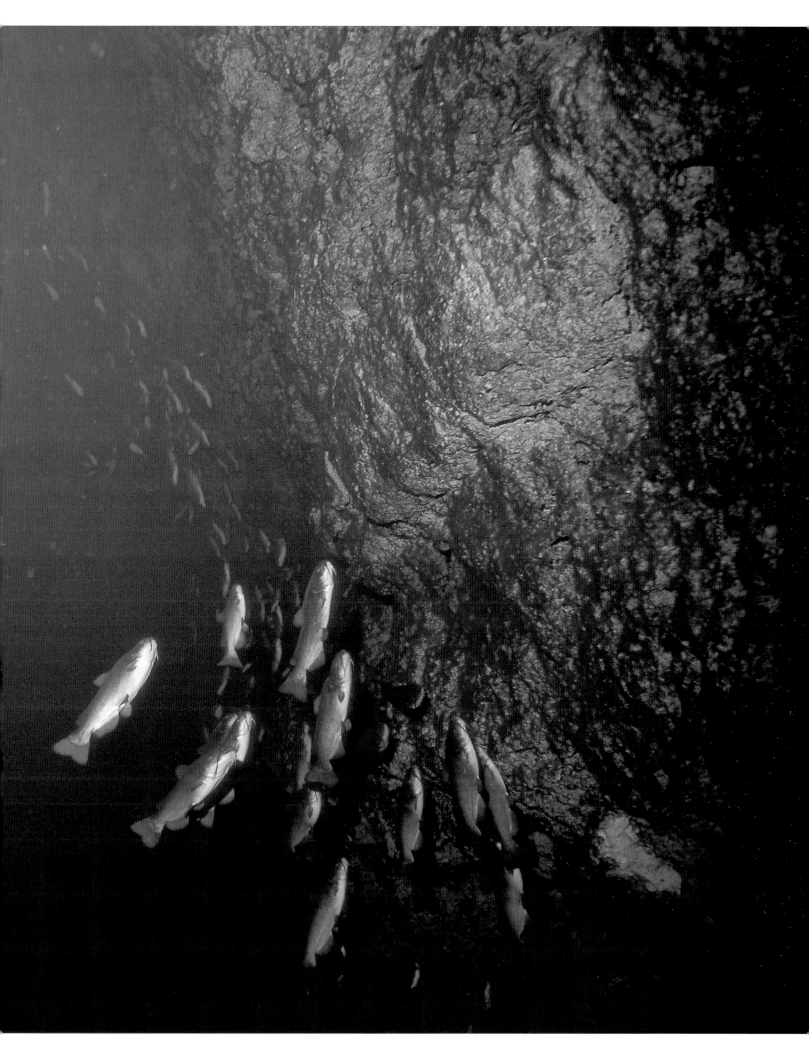

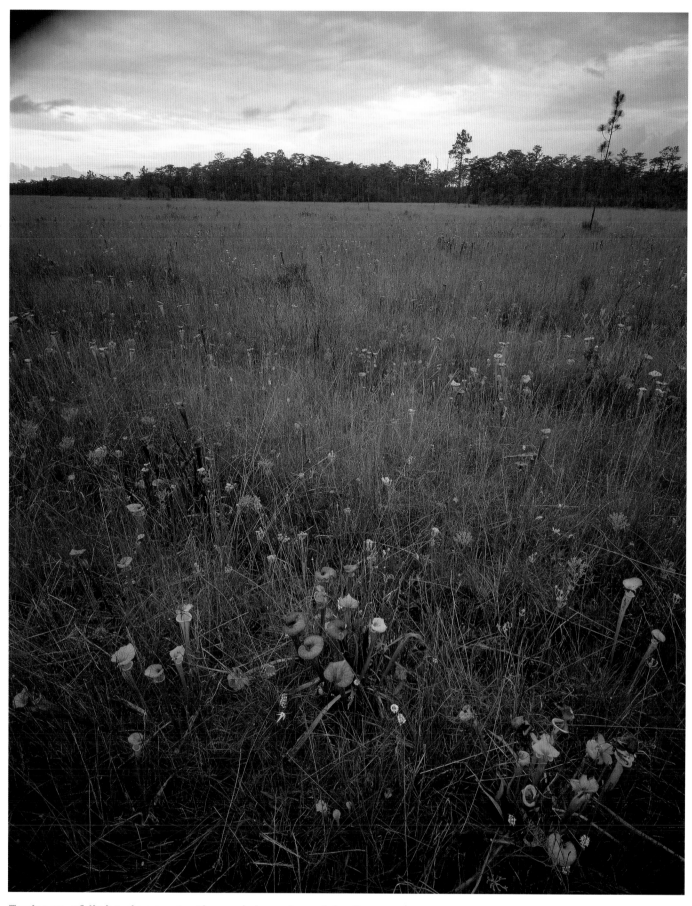

Embers of light decorate the celebrant prairie floor.

One of Florida's most valuable habitats, the wet flat, is dominated by carnivorous plants of many species—among the greatest number of species per square meter in the country. Upwards of 50 species of herbs grow in any square plot 39 inches on a side in this wetland wonderland. *Apalachicola National Forest, Sumatra.*

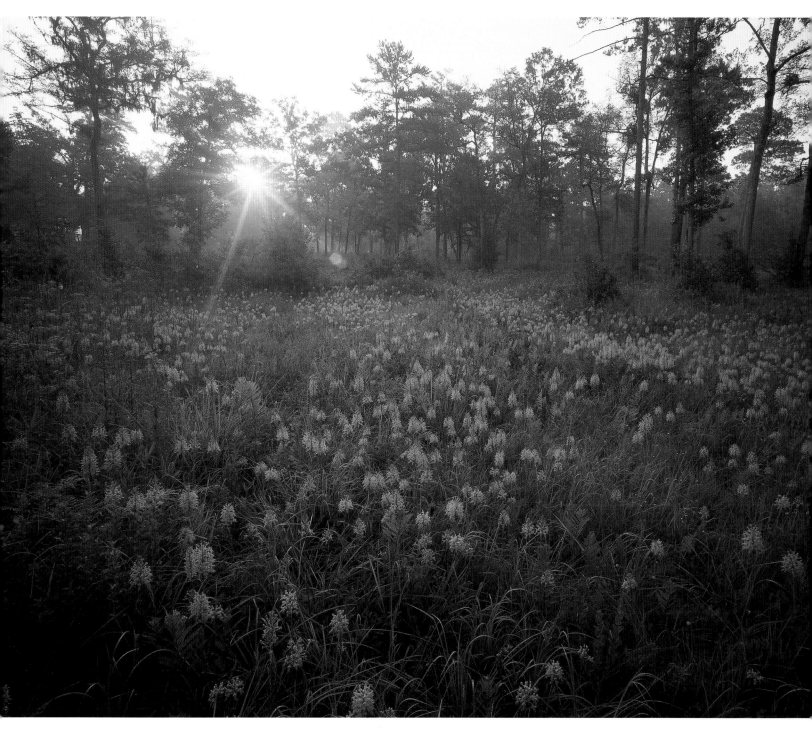

Heaven is here to stay in every way.

Another type of wetland, the hillside seepage bog, is emblazoned here with the yellow-fringed orchid *(Platanthera ciliaris)*. Seepage from hillsides creates moist soil and conditions for special plants such as sundews, hatpins, yellow-eyed grasses, sedges, ferns, and ground orchids. *Tallahassee Red Hills region, Tallahassee.*

A small stream flows through a steep-walled canyon in deep sands. Spring waters emerging from the head of the valley form a peculiar amphitheater called a steephead. Steepheads are commonest in Florida, but valleys created by the sapping of water from loose materials have also been observed on Mars. *Mike Roess Gold Head Branch State Park, Keystone.*

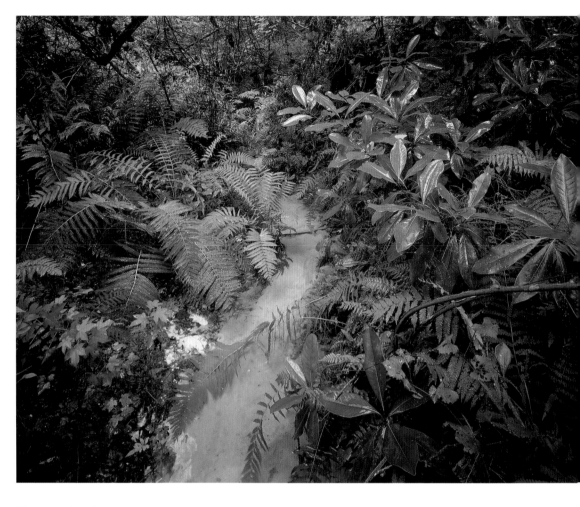

Nature's abundance creates beauty for the soul.

Venus hair *(Adiantum capillis-veneris)* and maiden (*Thelypteris* sp.) ferns grow under the canopy of a hardwood hammock surrounding a sinkhole. Limestone close to the surface of the ground and abundant water filling the sinkhole provide nutrients and moisture for a plant garden. *Paynes Prairie State Preserve, Gainesville.*

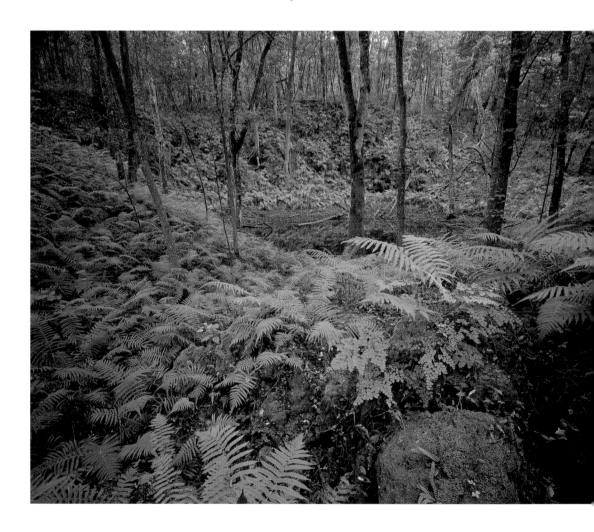

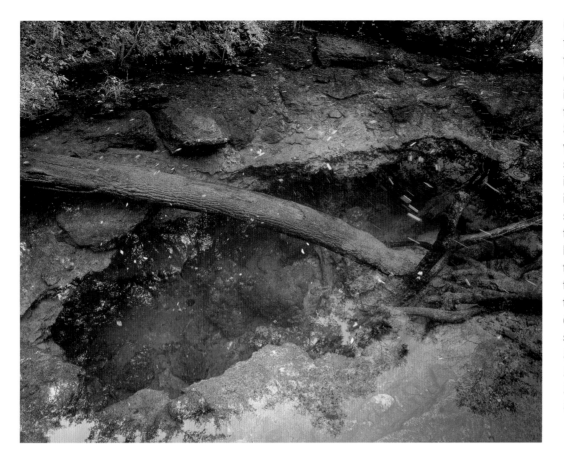

Clear water emerging from limestone flows through thousands of miles of underground caverns in Florida. Chances are, from Tampa to Defuniak Springs, the well water you drink comes from such a tunnel. Water flowing through these tunnels is called the Floridan aquifer system. It discharges from the aquifer when the hydraulic head, formed in the tunnels far up-gradient, forces it to the surface, thereafter to flow as one of Florida's fantastic spring-run rivers. *Cow Springs, Wes Skiles Peacock Springs State Preserve, Suwannee County.*

Beneath the surface, nature works quietly to purify all things

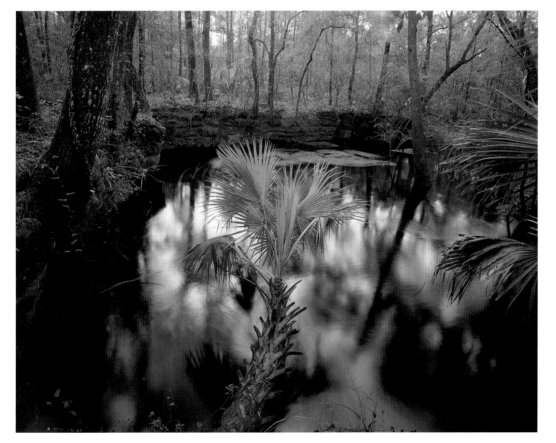

Some underground rivers flow in tunnels close to ground surface. When a segment of the ceiling collapses, a window to the nether-world opens. In this case, blackwaters of the upper Aucilla River are exposed in a series of such windows not far downstream from the first underground disappearance of the river, called a swallet. The Florida Trail runs along this stretch of the river. *Aucilla River, Jefferson County.*

Framed by spring blossoms of pinxter azalea *(Rhododendron canescens),* the languid Santa Fe River disappears underground in this river sink—another swallet— only to resurface three miles away in the River Rise Preserve State Park. *O'Leno State Park, High Springs.*

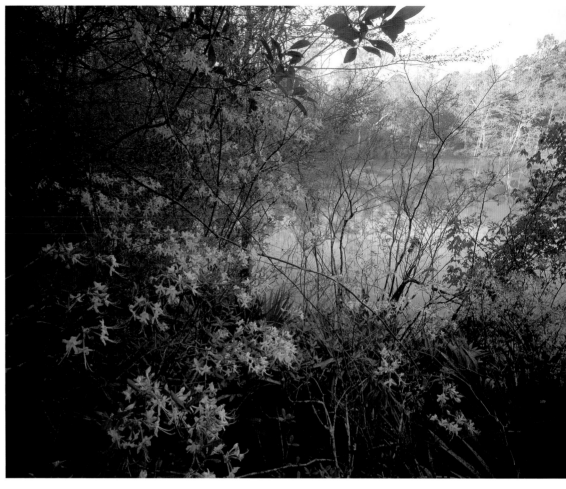

Flowers and water reflect divine love from the Earth.

Through the boughs and reflection of a bankside liveoak *(Quercus virginiana),* the Santa Fe River emerges from underground cavities in limestone, flowing on ground surface once again. Fish and water-breathing animals pass easily upriver underground, but air-breathing animals must either walk upstream or turn back at this river rise. *River Rise Preserve State Park, High Springs.*

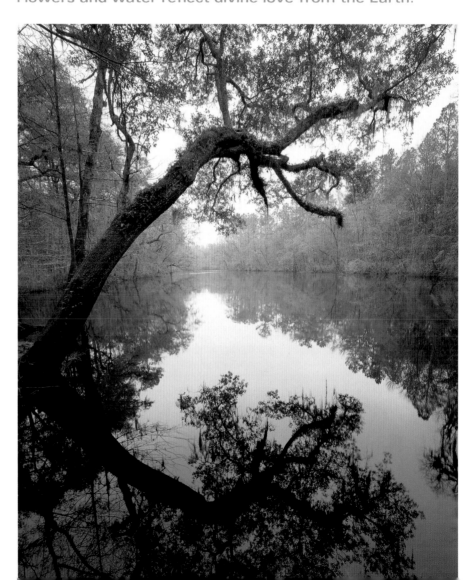

Florida's high annual rainfall (55–60 inches) works its way underground to flow through the caverns of the Floridan aquifer system. The cool, drinkable waters eventually emerge to form the head-waters of Florida's 720 springs. Exposed roots indicate low-water conditions, but bases of the trees are swollen only about 36 inches above the present water level, indicating an important rule: spring-run rivers rarely flood. *Ladies Parlor Spring on Silver River Run, Silver Springs.*

Oasis of Florida — sacred places to cleanse the mind, body and soul.

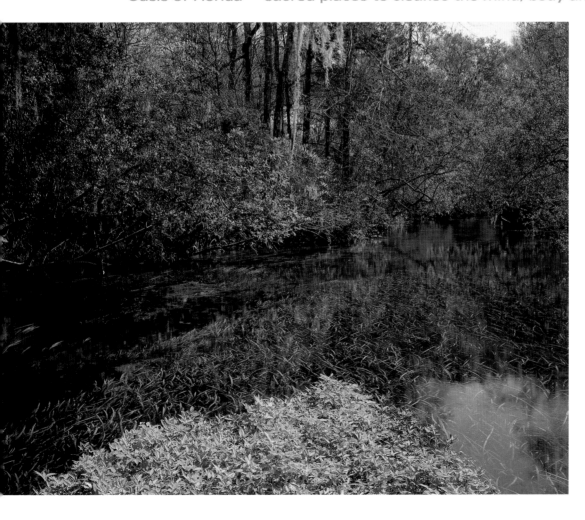

Seen underwater here, tape-grass or eelgrass *(Vallisineria americana)* once dominated the beds of Florida's spring-run rivers. It and other luxuriant river vegetation once fed mastodons, tapirs, giant beavers, and other now-extinct giant animals. The proof lies in their bones, preserved in the bottom sediments. Exotic plants have taken over many of Florida's valuable waterways—but not here. *Ichetucknee Springs State Park, Fort White.*

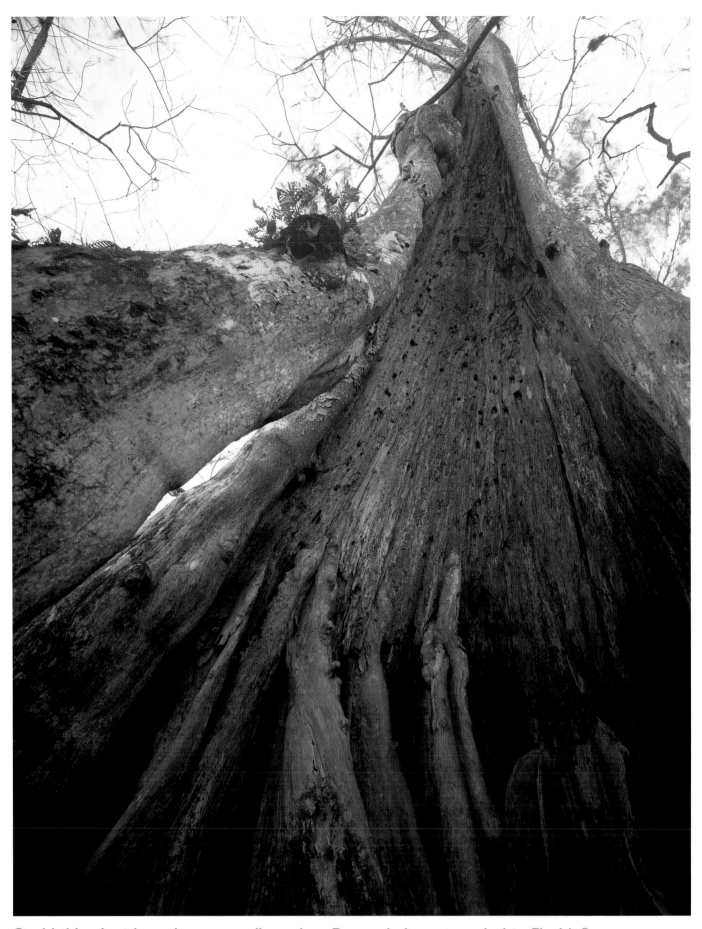

Could this giant have been a sapling when Ponce de Leon traveled to Florida?

Baldcypress *(Taxodium distichum)* is a tree of superlatives. A member of the redwood family, it can live for more than a thousand years. Although a conifer, it sheds its needles in winter. Its sapwood is highly resistant to rot, enabling a tree such as this one to survive a massive injury. Growth since the injury is curling from both sides over the exposed interior wood. *Headwaters of Green Swamp Wildlife Management Area, Green Swamp, Sumter County.*

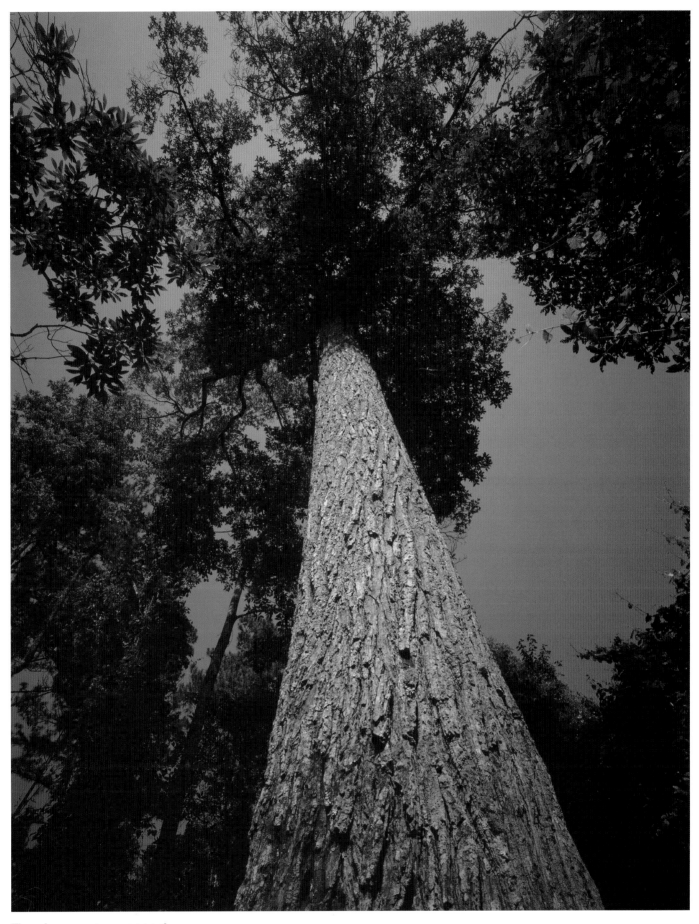

Trunks . . . truncated

When Europeans arrived in North America, they gave the name "bay" to any plant with lanceolate, dark green, leathery, aromatic leaves. Leaves of Loblolly bay *(Gordonia lasianthus)* reminded them of their Mediterranean bay *(Laurus nobilis)*. This giant example is located near the *Florida Greenway Trial, Etoniah Creek State Forest, Putnam County.*

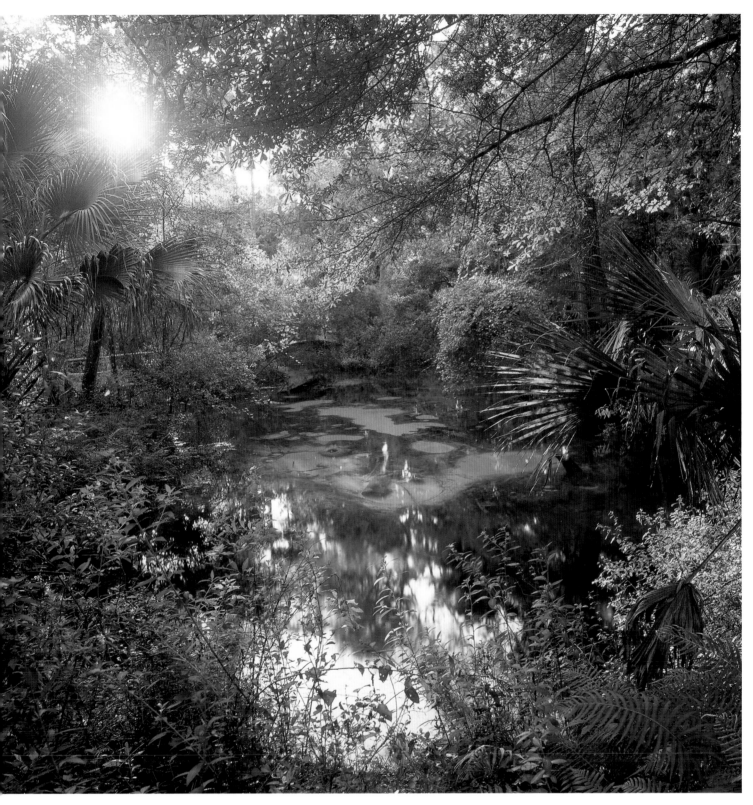

Sacred light drifts through the emerald waters.

Circulating groundwater in the Floridan aquifer system flows onto ground surface at low points in the landscape near the coast or larger rivers. Here the Floridan aquifer system discharges through the beautiful, sandy spring boils of Fern Hammock Springs, also known as The Aquarium. *Ocala National Forest, Marion County.*

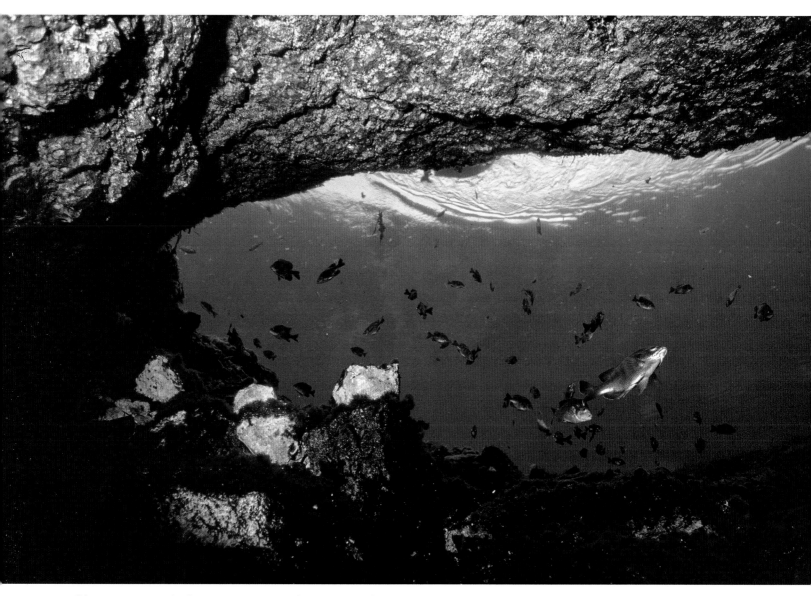

Clean, crystal clear water—a fountain of youth in each of us.

Caves in limestone originate as tunnels dissolved by circulating groundwater. Here the tunnel has collapsed to form a sinkhole out of which the groundwater flows called Silver Springs. From it crystal clear water becomes the lovely Silver River. *Silver Springs, Ocala.*

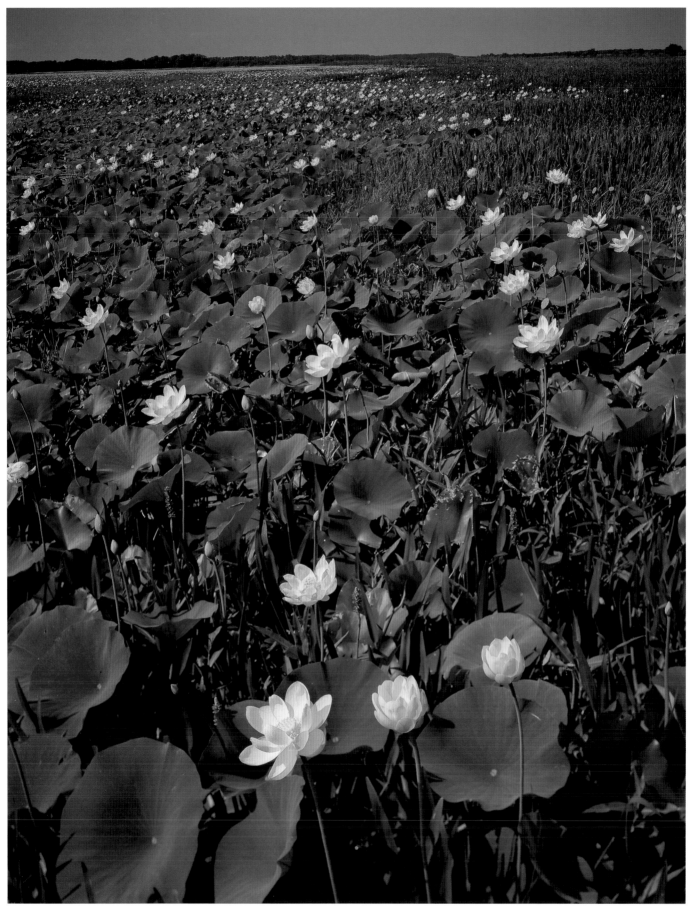

Delicately dance your thoughts across the golden-flowered lake of consciousness.

American lotus *(Nelumbo lutea)* and pickerelweed *(Pontederia cordata)* form a marsh wetland of emergent plants around the margins of lakes and ponds. Where the lake basin is wide and shallow, marsh is often more extensive than open water. *Lake Kissimmee State Park, Lake Wales.*

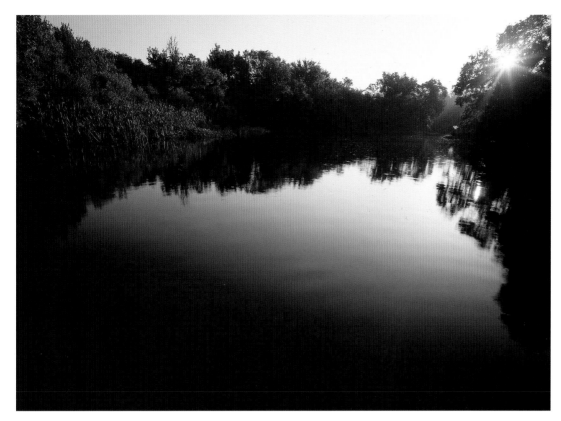

The Wekiva River, a state canoe trail and outstanding Florida water, is one of the few Florida rivers to receive the federal Wild and Scenic River status. Located near Sanford, it is spring fed and part of the 6,000-acre *Wekiva River Aquatic Preserve.*

Stillness . . . the journey into peacefulness . . . a oneness with your inner calmness.

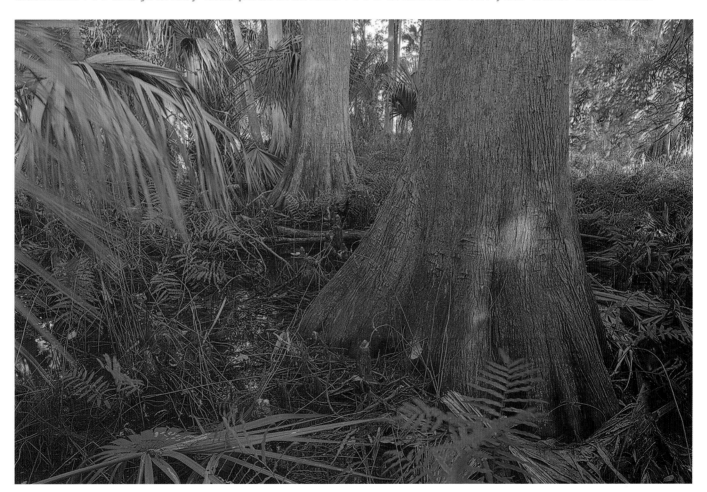

Stillness . . . the journey into peacefulness . . . a oneness with your inner calmness.

Botanists do not agree on whether there are one or two species of cypresses (Taxodium). Those that grow in flatwoods ponds and other wetlands that dry periodically are called pond cypress. Although cypress can live for more than 1,000 years, most of commercial value were logged in the 1800s. In the absence of competition, cypress can grow rapidly. These may be less than a century old. The short cypress knees and lack of greatly swollen butts indicate that high water levels in this wetland do not rise more than one to three feet. Moreover, the red, pointed tops of the knees indicate a relatively young age of the trees. *Crescent J. Ranch, Forever Florida, St. Cloud.*

The Rainbow Springs complex is an aquatic preserve at the Rainbow River headwaters. One of the clearest springs in Florida, it once was under development as a bustling commercial attraction, spoiling its natural beauty. Purchased by the state of Florida in 1992, it has been restored to its natural state. *Rainbow Springs State Park, Dunnellon.*

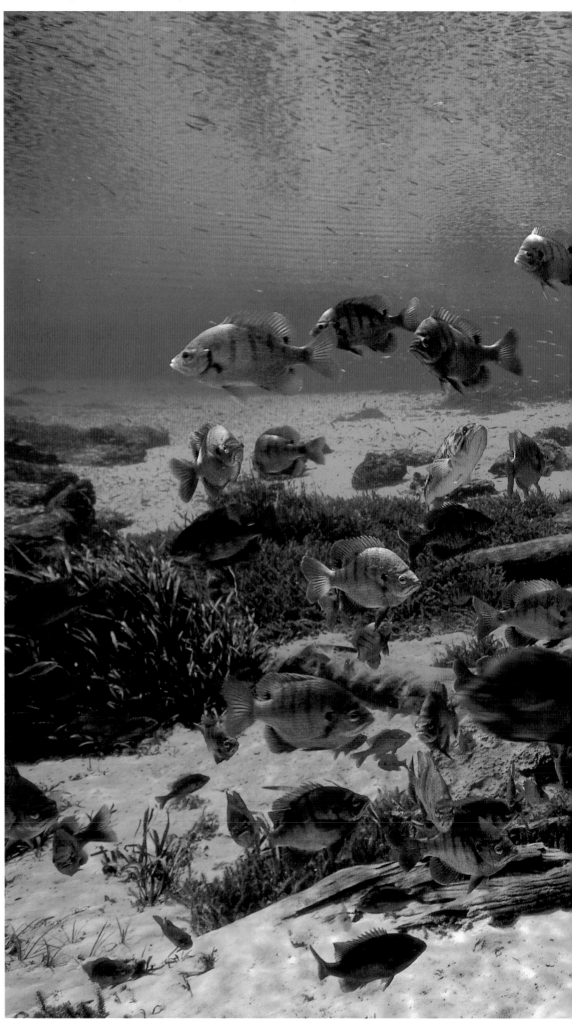

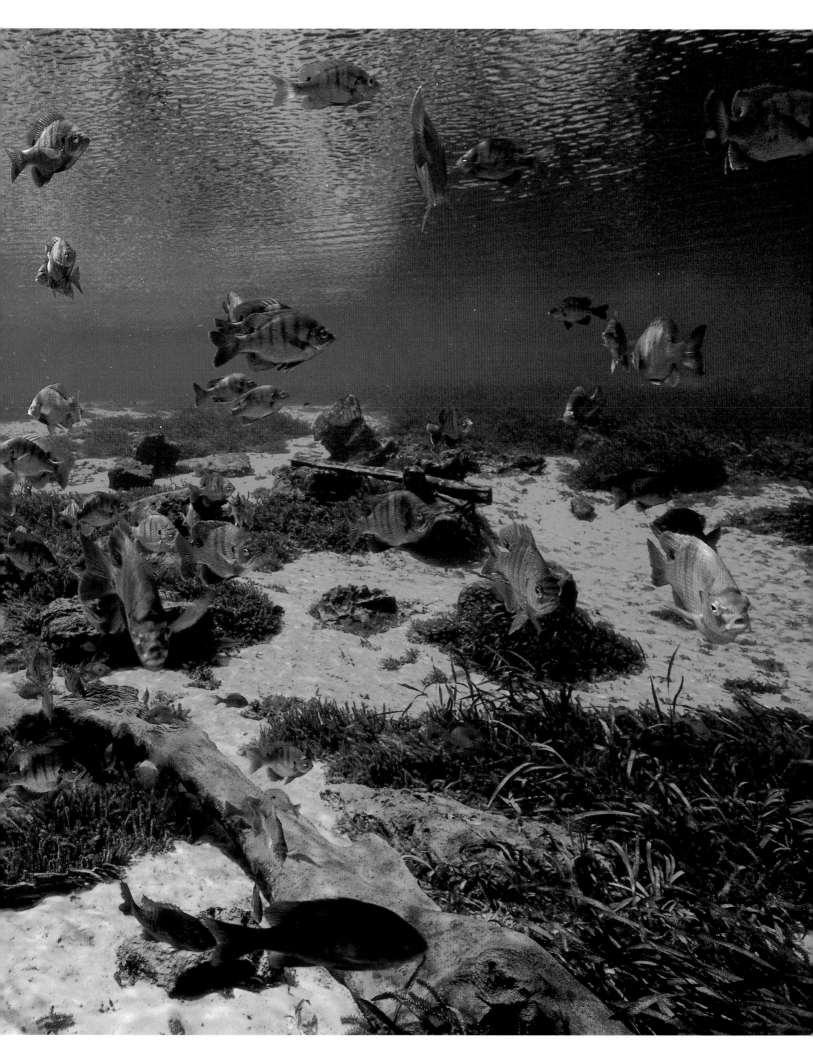

The Florida softshell turtle *(Apalone ferox)* swims among tubular rushes at one of the clearest, spring-fed, sandy-bottom lakes in the state. One or more species of bream *(Lepomis* sp.) inspect the lake bottom for a suitable nesting site, called a bed. *Lake Johnson complex, Mike Roess Gold Head Branch State Park, Keystone Heights.*

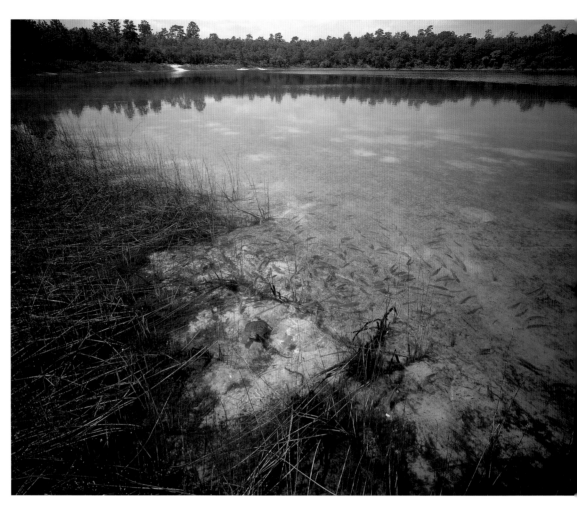

The water dance continues . . . softly or wildly.

Multiple trunks of Ogeechee tupelo *(Nyssa ogeche)* shed their autumn leaves into the Suwannee shoals. Limestone provides riffles and a hard bedrock substrate for fish and aquatic life, an unusual condition in most Florida rivers. *Big Shoals State Park, north of White Springs.*

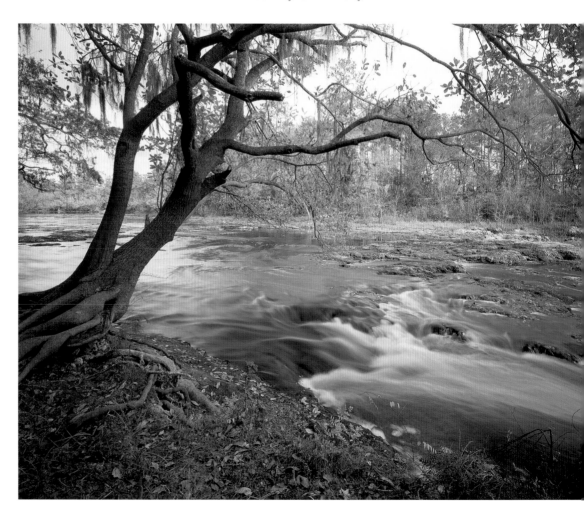

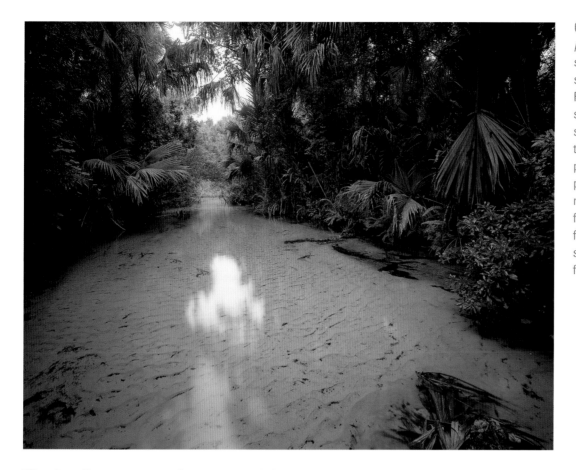

Cabbage palm *(Sabal palmetto),* the Florida state tree, flanks a spring-run river in central Florida. Clear water spreads out over a sandy streambed, wicking into the peaty soils under the palms, slowing decomposition. During heavy rains, tea-colored water flows out of the palm forest and will discolor the stream until the runoff is flushed. *Seminole County.*

The healing power of water and flowers guides us into a peaceful reunion with our source.

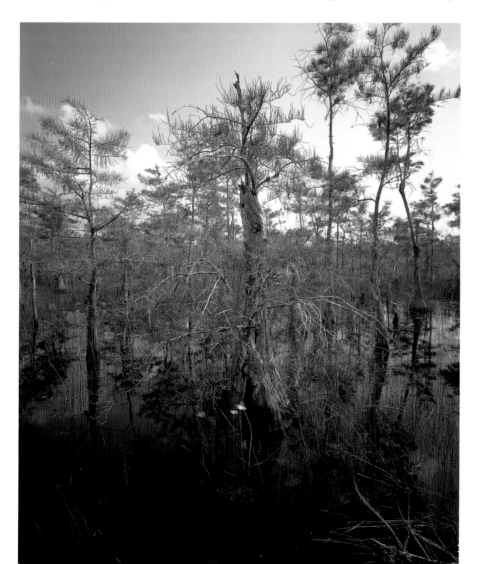

Dwarf cypress trees grow in an acid swamp with marsh pink *(Sabbatia bartrami)* and rushes. Pond cypress *(Taxodium ascendans)* is found throughout Florida, occasionally in places having harsh growing conditions such as being flooded with acid waters for part of the year and then, in contrast, having severely dry soils during seasonal dry periods. CREW WEA consists of three units—Corkscrew Marsh, Flint Pen Strand, and Bird Rookery Swamp—totaling more than 28,000 acres and is part of the 60,000-acre Corkscrew Regional Ecosystem Watershed land acquisition project. *Corkscrew Regional Ecosystem Watershed, Lee and Collier Counties.*

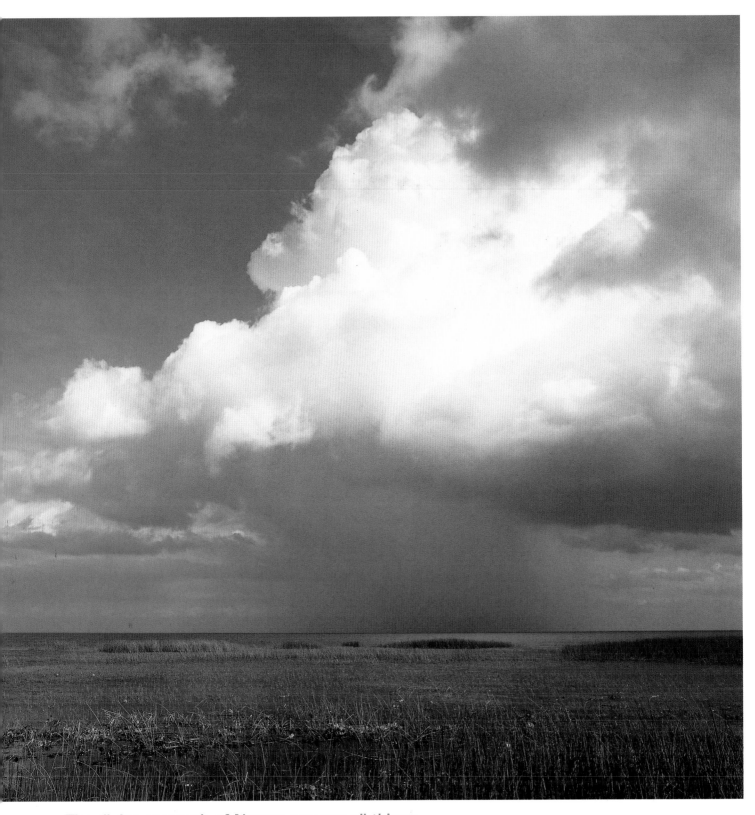

The divine strength of Nature powers all things.

An afternoon thundershower sweeps across Florida's largest lake. With an average depth of nine feet and nowhere deeper than twenty feet, it is also the second largest freshwater lake—after Lake Michigan—inside the continental United States. Its waters feed the expansive marshes of the famous Everglades. *Observation Shoal, Moonshine Bay, Lake Okeechobee, Glades County.*

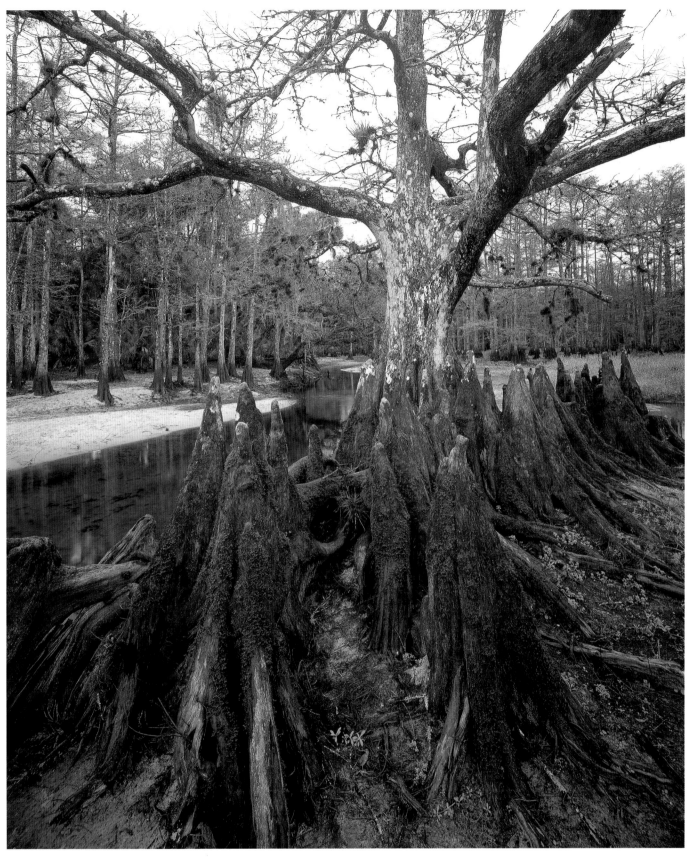

Nature works in cooperation to provide life.

Knees and the swollen butts of baldcypress *(Taxodium distichum)* rise to the average high-water level of a local site, clearly demonstrated by the knees of this old, branched cypress. Across the river, the high-water mark is obvious on younger cypresses where white lichens have been killed by recent high-water stands, and whose slow-growing knees have yet to reach the high-water line. The Fisheating Creek Management Area consists of 8,435 acres of prairie, baldcypress swamps, and hardwood hammocks. *Fisheating Creek Management Area, Glades County.*

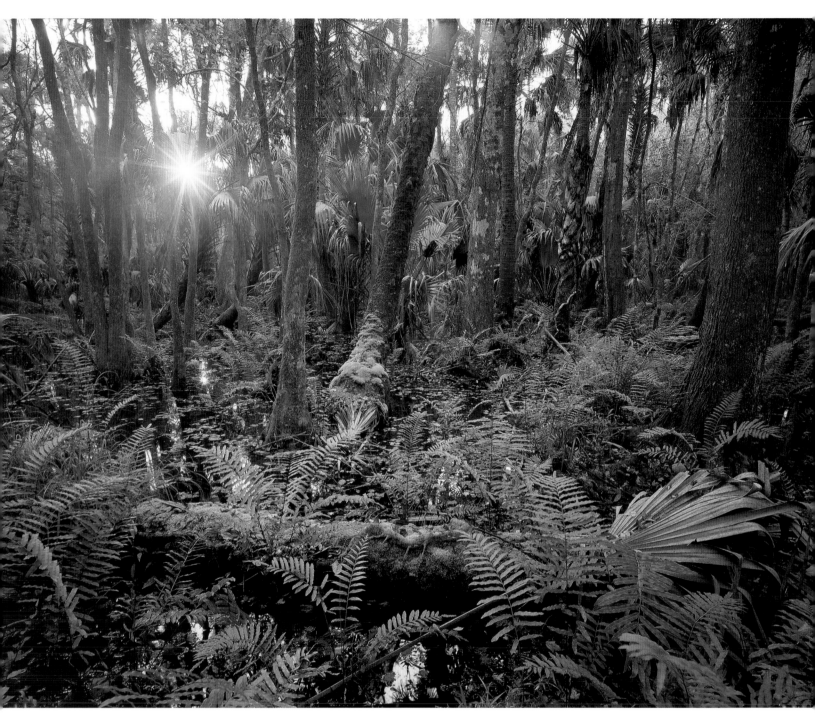

A swamp immediately recycles . . . swirling everything into itself . . .
no log unturned . . . no thought standing still.

In order to reproduce, most ferns and mosses have motile gametes that must swim to each other, so high humidity and standing water in swamps is prime habitat for them. Cabbage palms and blackgum trees *(Nyssa sylvatica)* grow in this wetland, too. Any forested wetland is a swamp, by definition. Opening to the public in 1931, this park was established when local citizens came together to promote the hammock as a candidate for National Park status. *Highlands Hammock State Park, Sebring.*

Swamp and sunlight resurrect together . . . a birthright heard around the world.

Resurrection fern *(Pleopeltis polypodioides)* grows on a leaning liveoak *(Quercus virginianus)* in a cabbage palm grove. Exposed in the air during drought, resurrection fern can lose more than 95% of its water, causing its fronds to roll up into a tight ball. Here we see they are open, indicating that it has rained here recently. *Myakka River State Park, Sarasota County.*

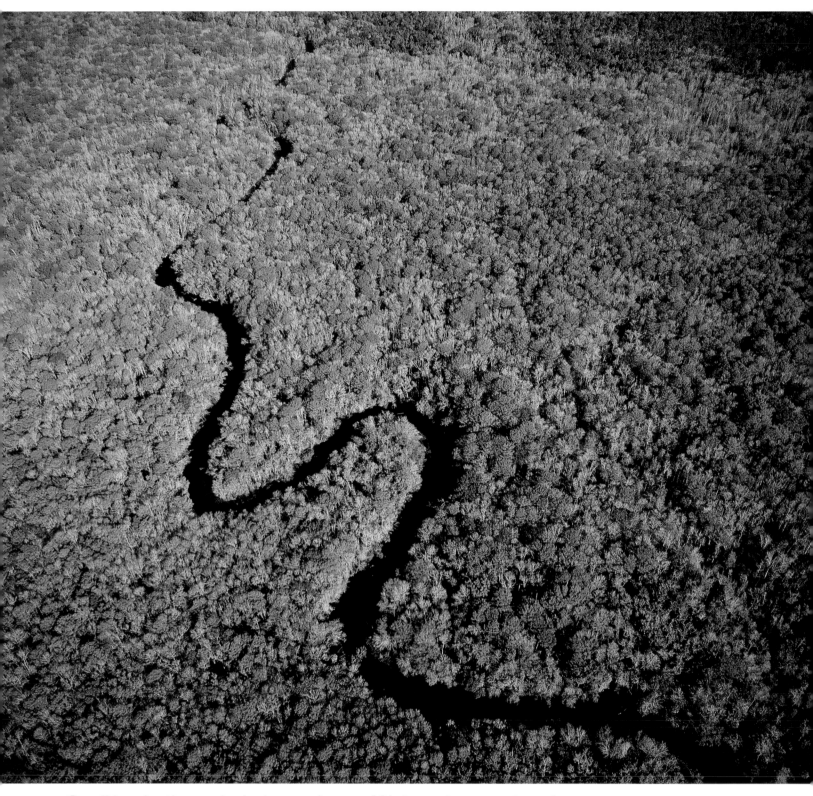

On all levels, the ecological sacredness of Nature always astounds us.

Designated an Outstanding Florida Water, the Ocklawaha River winds its way through a bottomland swamp, created partly by its own overflow and partly from seepage coming in from adjacent uplands. Flowing north out of marshy lakes northwest of Orlando, it is refreshed by spring waters of Silver River, but its course to the St. Johns River is interrupted by the failed Cross Florida Barge Canal. This is the widest section of the Ocklawaha River floodplain swamp forest. *Marion County*.

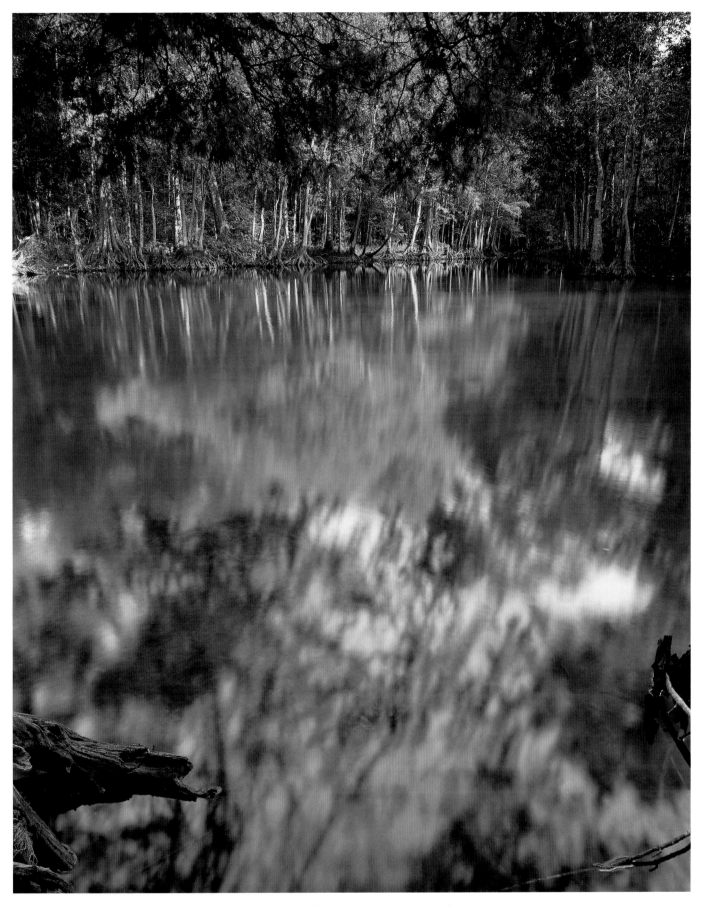

Each element in Nature's storehouse reflects upon its perfect purpose.

Blackwaters of the upper Ocklawaha River, against the far bank, are here diluted by the crystal-clear spring waters of Silver River in the foreground. Steamboats once plied the lower Ocklawaha from the St. Johns River to Florida's famous Silver Springs. This is not now possible because of Rodman Dam and Reservoir, created for the Cross Florida Barge Canal but left intact after the project was abandoned. *Silver River/Oklawaha River Intersection, Marion County.*

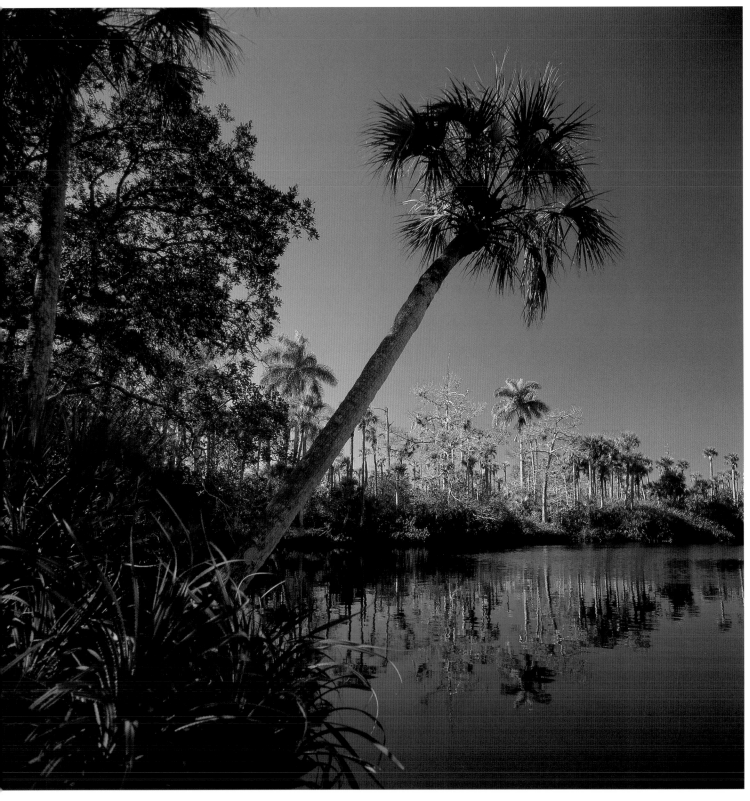

Florida's Wilderness Watersphere is a continued dance into time.

The Loxahatchee River, Florida's first nationally designated Wild and Scenic River, meanders through a cypress swamp with cabbage palms. The watershed also contains diverse biological communities such as pinelands, xeric oak scrub, hardwood hammocks, freshwater marshes, wet prairies, mangrove swamps, seagrass beds, tidal flats, oyster beds, and coastal dunes. *Loxahatchee River, Jonathan Dickinson State Park, Hobe Sound.*

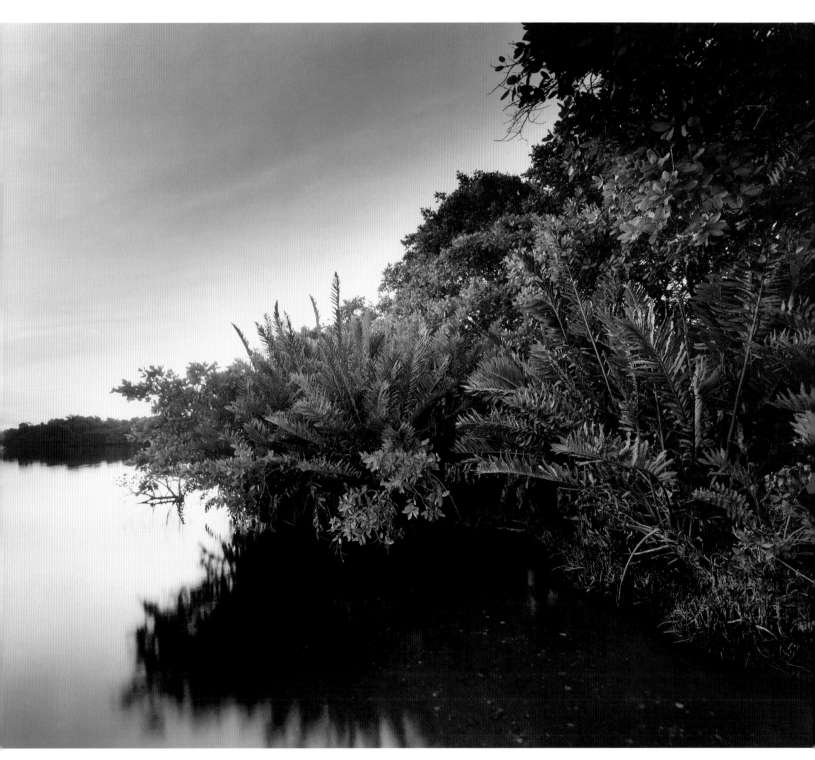

Rivers transcend time with their endless journey.

In 2001, the eighteen-acre mangrove Manatee Island was donated by the Florida Power and Light Company as the first addition to the Caloosahatchee National Wildlife Refuge, established in 1920 by President Woodrow Wilson as a preserve and breeding ground for birds. The island is located adjacent to the Florida Power and Light . Fort Myers Plant, whose warm water outflow is a major overwintering area for the endangered West Indian manatee. *Manatee Island, Caloosahatchee National Wildlife Refuge, Fort Myers.*

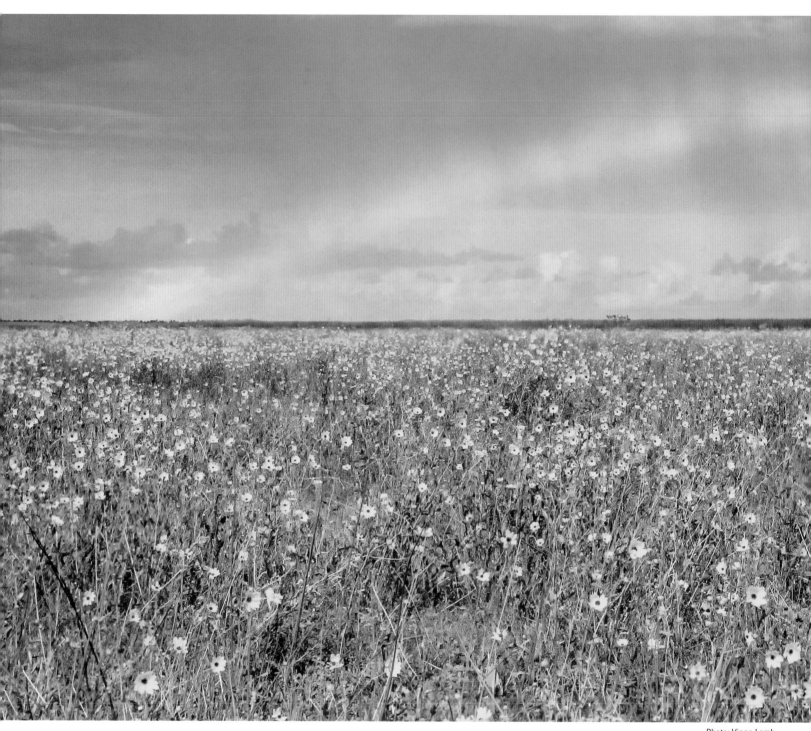

Photo: Vince Lamb

La Florida, the Land of Flowers, you have many admirers.

A celebration of sunflowers *(Helianthus agrestis)* blooms in the wetlands along St. Johns River in central Florida. *Lake Jesup, north of Orlando.*

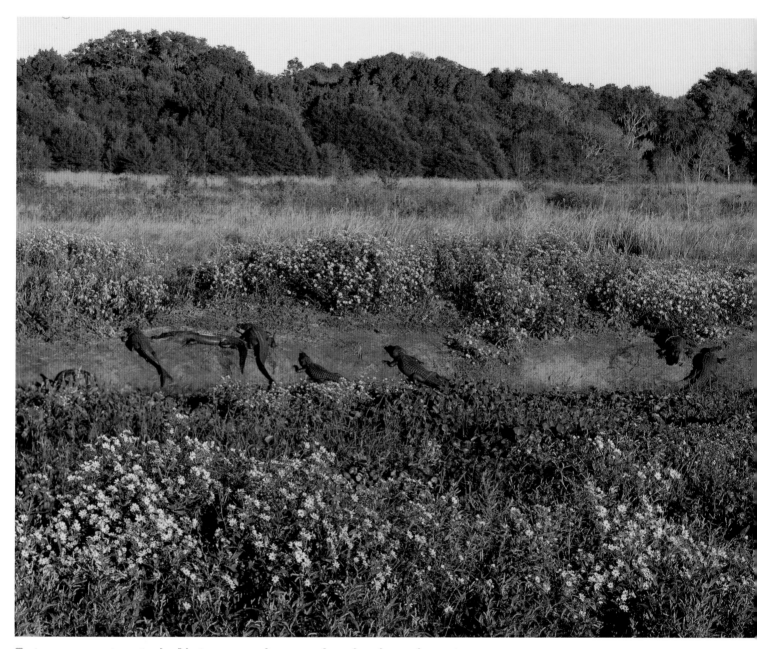

Extreme contrasts in Nature can harmoniously share beauty.

The American alligator *(Alligator mississippiensis)* once was hunted for its hide so exhaustively that it became one of the country's first threatened species. That protection, and the alligator's hardiness, allowed the species to rebound in such numbers that it was taken off the endangered species list. Now it is so common that in many places it is a nuisance that requires removal by agents of the Florida Fish and Wildlife Conservation Commission. This same panorama of alligators sunning at the Alachua Sink in Paynes Prairie may have been viewed by none other than William Bartram in the late 1700s. *Paynes Prairie State Preserve, Gainesville.*

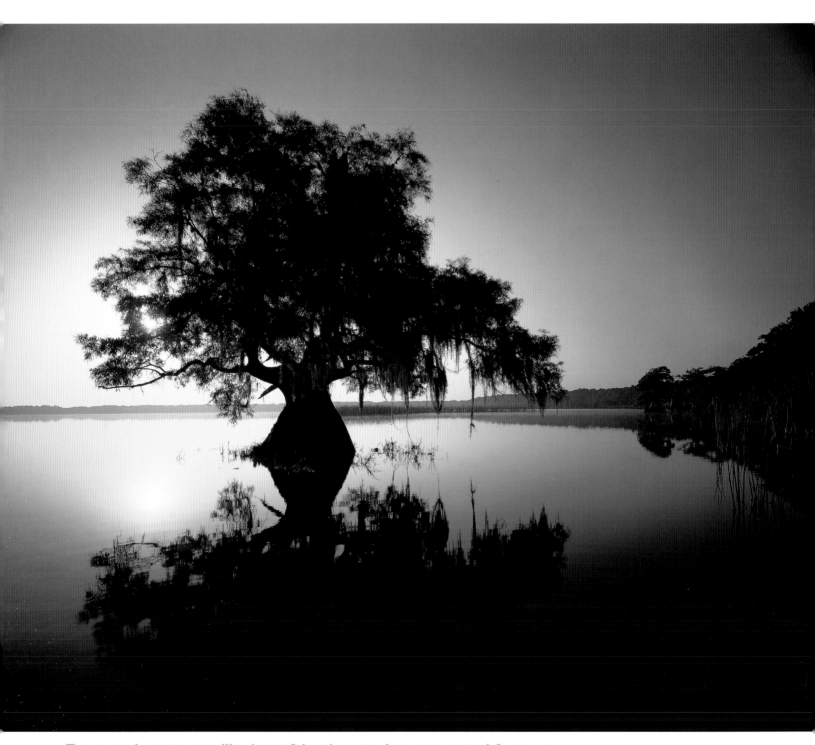

Trees and water are like best friends—staying connected forever.

A lone baldcypress *(Taxodium distichum)* on Lake Russell, which is one of the last undeveloped lakes in central Florida, gives evidence of its life history in silhouette. The swollen trunk indicates that high water in most years has not risen above the level of the shoreline in the background. Its low, rounded crown indicates that, during the life of this tree, it probably grew out in full sunlight without any competition for light. *Walt Disney Wilderness Preserve, south of Orlando.*

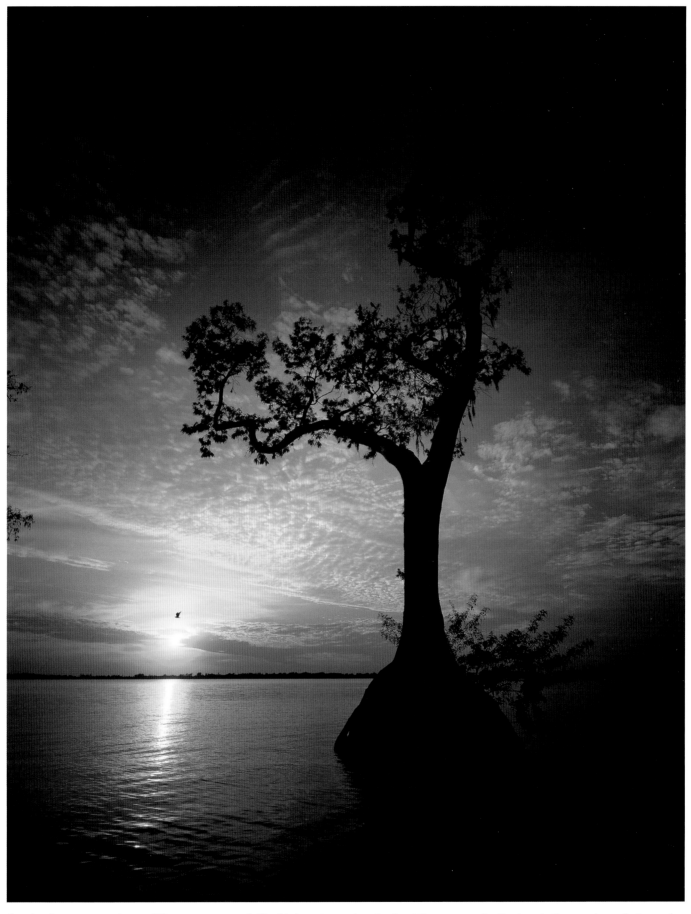

Another lone cypress has a different story to tell. The high-water regime is about the same as for the tree in the previous photograph, but the height of the tree and its lack of a bushy crown indicate that in its early life several hundred years ago, it was compelled to grow high by the presence of other trees—now long gone. *Cypress Gardens, Winter Haven.*

False dragonhead *(Physoste-gia purpurea)* grows on the steep, limestone bank of an outside bend, where river waters run deepest. Across the river, sandy soils of the inside bend support Carolina willow *(Salix caroliniana),* a classic colonizing species of newly deposited sediments on river point bars such as this one. The Peace River drainage basin is approximately 2,350 square miles in area. The river flows about 105 miles from the confluence of the Peace Creek Drainage Canal and Saddle Creek to Charlotte Harbor. *Peace River, DeSoto County.*

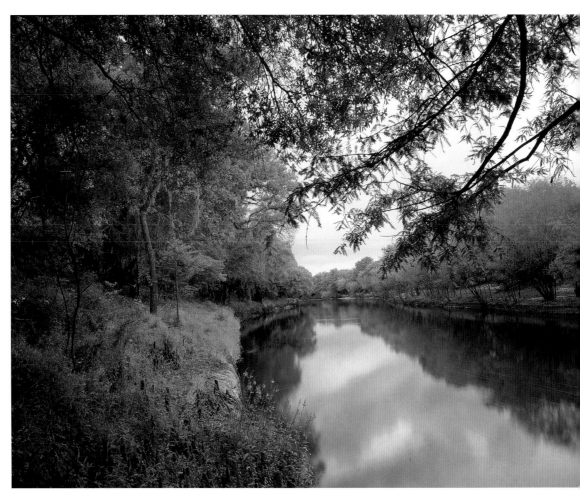

What ancient secrets do the rivers know?

Marshpennywort (*Hydrocotyle* sp.) grows among the knees of a baldcypress *(Taxodium distichum)* on an outcropping of limestone rocks that has created a rapids. Knee height and the swollen butt of the cypress indicate that the river doesn't rise very high locally, but the bent and gnarly knees show evidence of abrasion from debris during high water. *Hillsborough River State Park, Thonotosassa.*

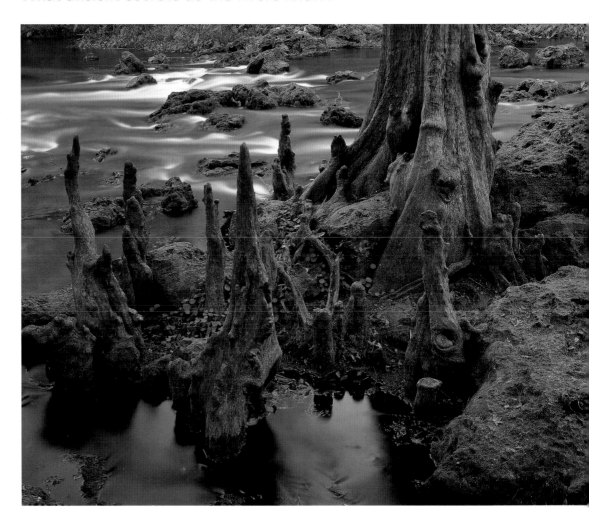

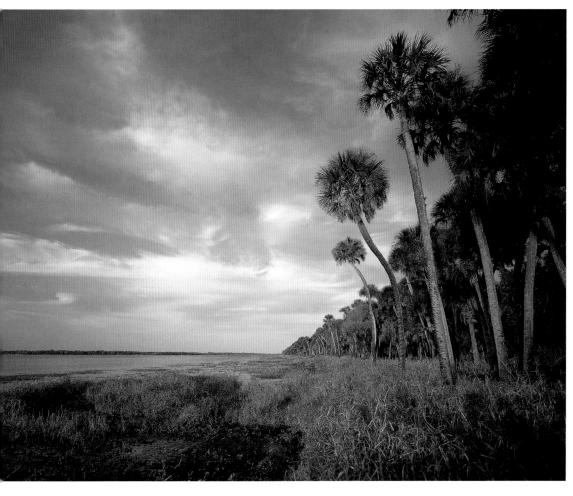

Maidencane *(Panicum hemitomum)* marsh fringes a two-square-mile lake formed in the middle of the Myakka River, Florida's second to be designated a Wild and Scenic River. The river flows through 58 square miles of wetlands, prairies, hammocks, and pinelands, and the state park protects hundreds of species of plants and animals. *Myakka Lake, Myakka River State Park, Sarasota County.*

Stillness in Nature . . . stillness within . . . a perfect union.

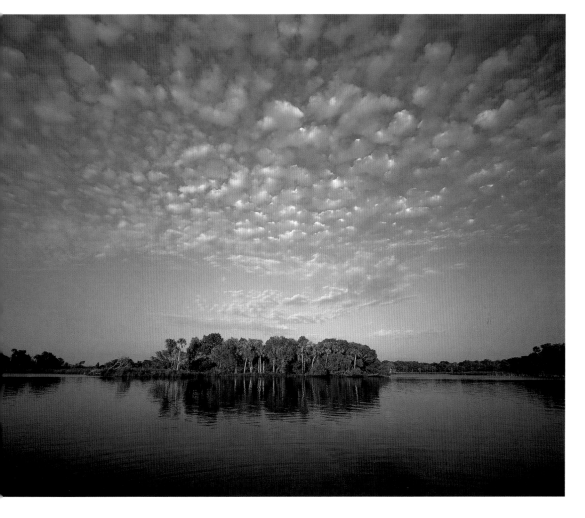

Rivers of Florida broaden near the sea where salt and fresh waters mix to create a brackish estuary. Here a sawgrass *(Cladium jamaicense)* marsh across the river surrounds a tree island dominated by cabbage palm *(Sabal palmetto)* and southern red cedar *(Juniperus silicicola)*. The Little Manatee River Preserve contains 1,902 acres. The Little Manatee River originates in a swampy area east of Fort Lonesome in southeastern Hillsborough County and flows generally westward for about 32 miles toward its discharge point into Tampa Bay. *Little Manatee River, Manatee County.*

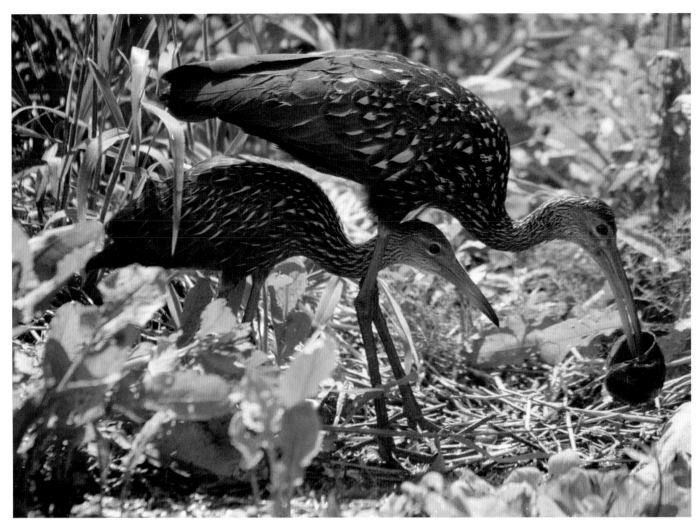

(Above) The Florida limpkin *(Aramus guarana)* eating its favorite diet, apple snails. *Myakka River, Sarasota.*

(Right) Only fifteen whooping cranes remained in 1941, but conservation efforts by the U.S. Fish and Wildlife Service are bringing the species back from the edge of extinction. A population in central Florida is growing, annually enhanced by juveniles that follow ultralight aircraft from breeding habitat in Wisconsin to wintering habitat in Florida. *Escape Ranch, Kenansville.*

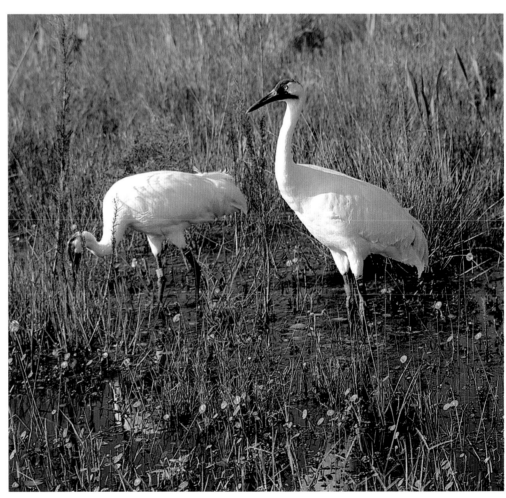

(Left) The Rainbow River Aquatic Preserve along the Rainbow River is known for its special native underwater vegetation such as tapegrass and sagittaria. In many parts of the state, native populations of aquatic vegetation are threatened by exotic species. *Rainbow River State Park, Dunnellon.*

(Below) Largemouth bass *(Micropterus salmoides)* is Florida's most sought-after freshwater game fish. It is a top predator, using its huge mouth to over-power fishes, frogs, crusta-ceans, small birds, small turtles, and small snakes. *Silver Run, Silver Springs.*

Water house—home of infinite beauty.

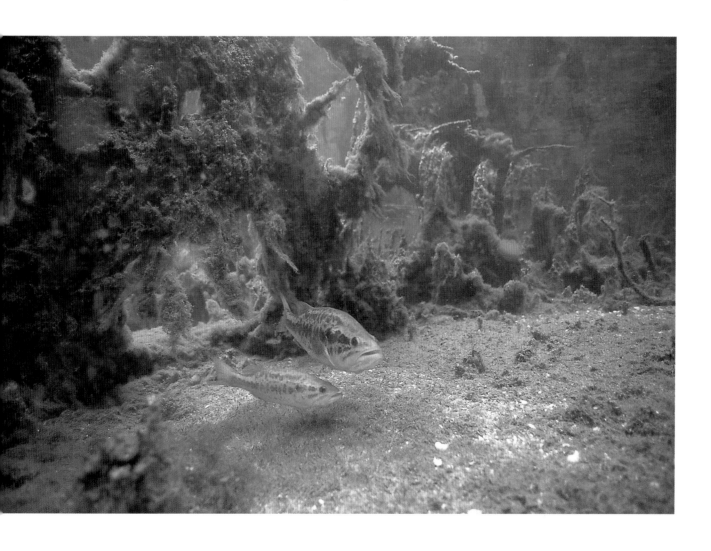

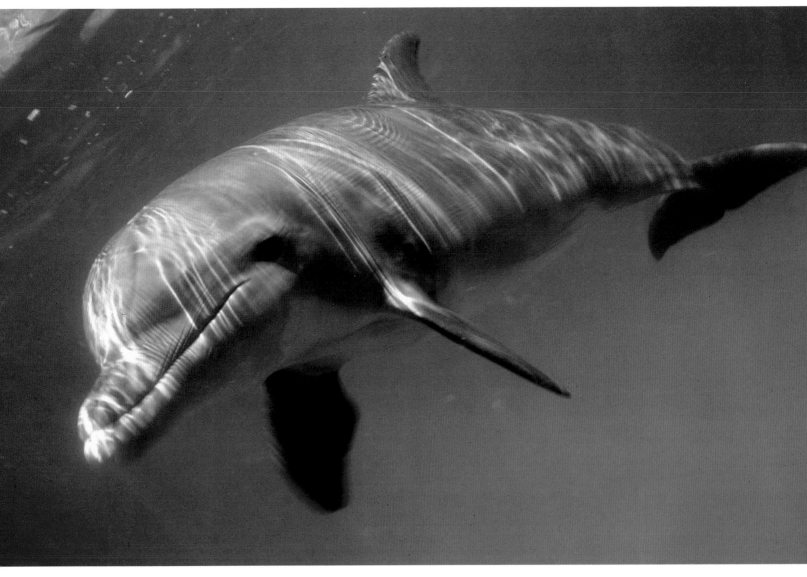

Dolphin mind, floating in a sea of infinite consciousness.

The bottlenose dolphin *(Tursiops truncatus)*, mistakenly called porpoise, is Florida's most common sea mammal. Adults are typically 6 to 12 feet long and can eat more than 20 pounds of fish and marine invertebrates each day. Bottlenose dolphins show a high degree of intelligence, have a wide range of vocalizations, and may cooperate in fishing or taking care of injured dolphins. They have been known to live into their 50s and reach weights from 300 to 1,400 pounds. *Coastal waters off Shell Island, St. Andrews State Recreation Area, Panama City.*